THE MASTER GUIDE TO DRAWING CARTOONS

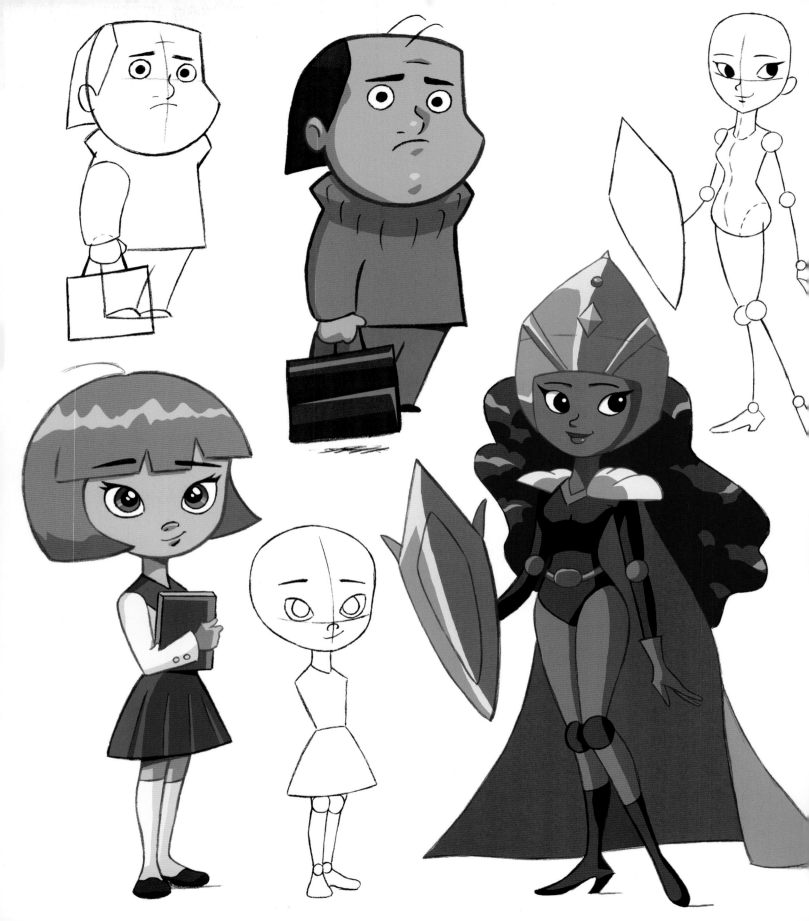

DRAWING WITH *Christopher Hart*

THE MASTER GUIDE TO DRAWING CARTOONS

HOW TO DRAW AMAZING CHARACTERS FROM SIMPLE TEMPLATES

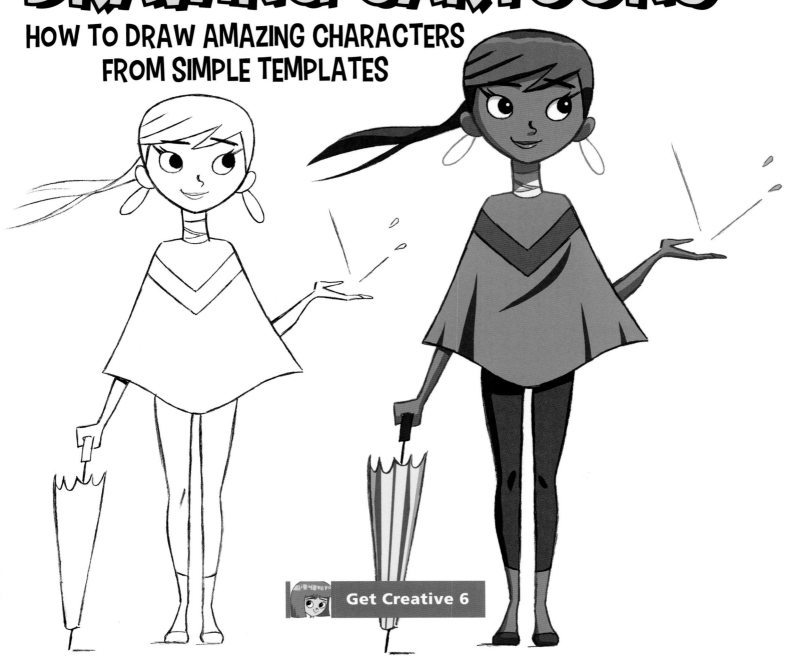

Get Creative 6

DRAWING WITH Christopher Hart

An imprint of **Get Creative 6**
19 West 21st Street, Suite 601, New York, NY 10010
sixthandspringbooks.com

Senior Editor
MICHELLE BREDESON

Art Director
IRENE LEDWITH

Coloring
ROMULO FAJARDO

Chief Executive Officer
CAROLINE KILMER

President
ART JOINNIDES

Chairman
JAY STEIN

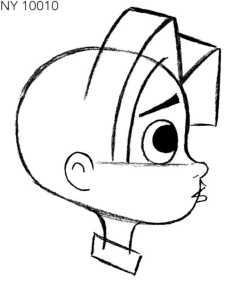

Manufactured in China

1 3 5 7 9 10 8 6 4 2

christopherhartbooks.com
facebook.com/CARTOONS.MANGA
youtube.com/user/chrishartbooks

Library of Congress Cataloging-in-Publication Data

Names: Hart, Christopher, 1957- author.

Title: The master guide to drawing cartoons : how to draw amazing characters from simple templates / Christopher Hart.

Description: New York, NY : Drawing with Christopher Hart, [2022] | Includes index.

Identifiers: LCCN 2021052654 | ISBN 9781684620395 (paperback)

Subjects: LCSH: Cartoon characters. | Cartooning--Technique.

Classification: LCC NC1764 .H3768 2022 | DDC 741.5/1--dc23/eng/20211203

LC record available at https://lccn.loc.gov/2021052654

For my four inspirations: Maria, Isabella, Francesca, and the naughtiest dog in the world, Spencer.

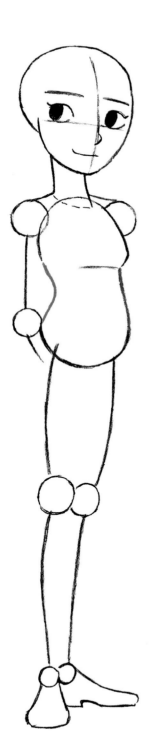
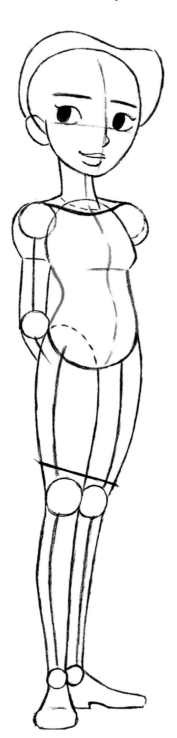
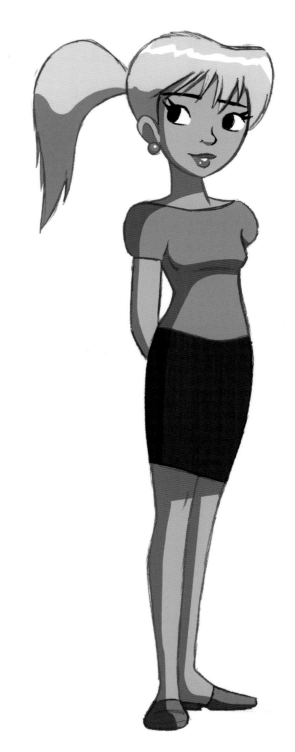

CONTENTS

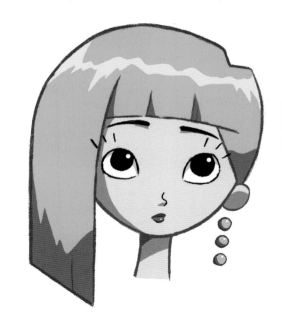

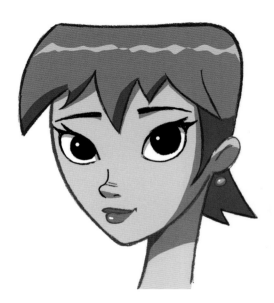

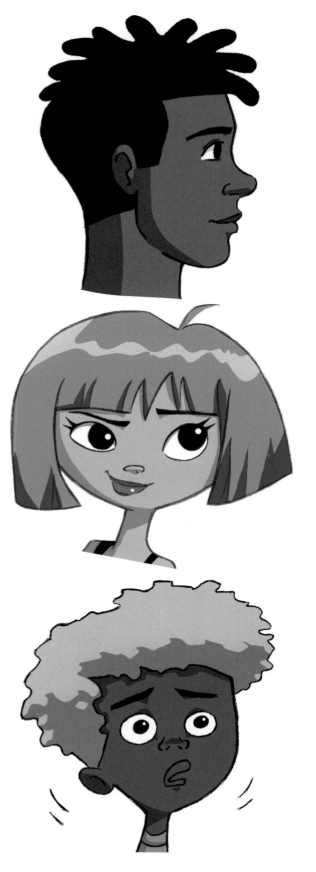

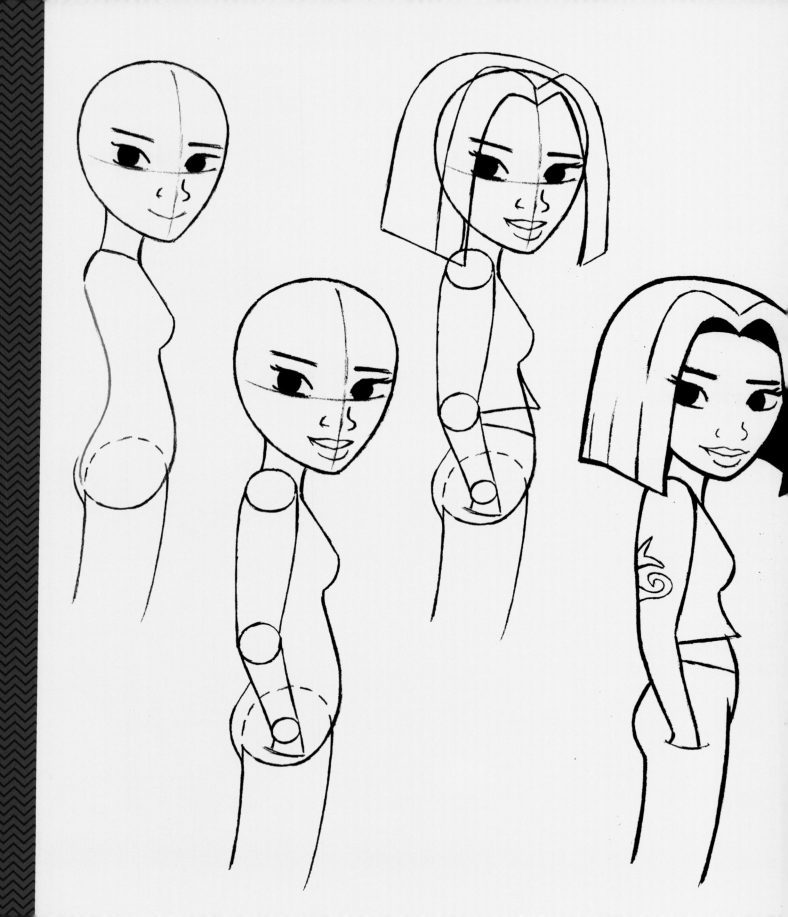

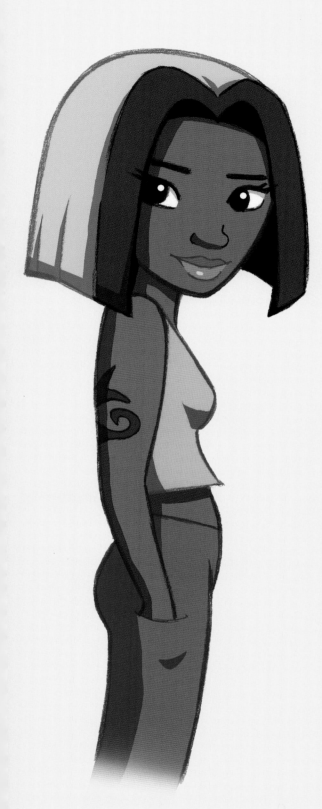

INTRODUCTION

I'm excited to introduce a new approach to drawing cartoons using simple templates as a starting point. A template is a basic version of a character that includes all the elements that are essential to the character.

You'll learn to draw attractive characters, teen types, funny kids, goofy dads, and other grown-ups, as well as unlikely heroes and villains. You'll also learn techniques for modifying characters, which you can use to invent your own.

I've also included essential techniques that demonstrate how to build original characters with cartoon proportions and how to pose them.

This book focuses on drawing characters in one of the most popular styles: movie animation. Animated characters are built logically, which is why you rarely see movie characters with two eyes on the same side of the head. The characters need to appear round so they can be turned at different angles. And roundness translates into an engaging look.

If you're ready to draw super-appealing cartoon characters, then you're right where you should be.

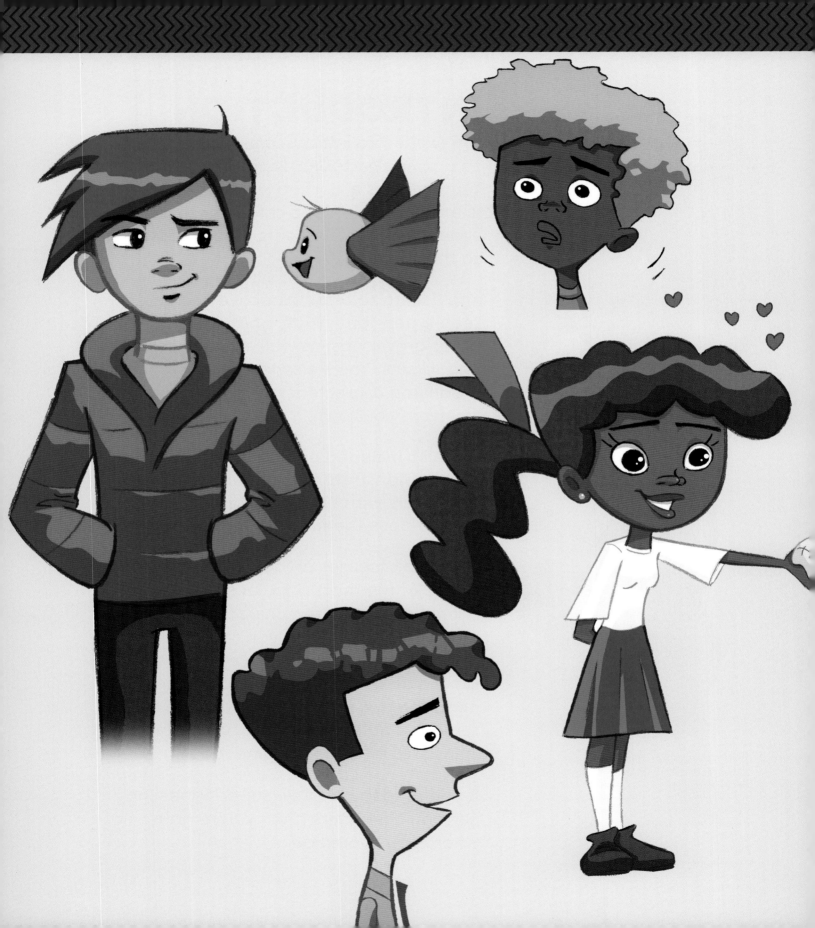

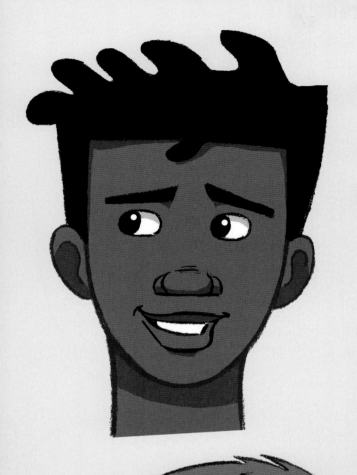

INVENTING ORIGINAL CHARACTERS

Cartooning is part art and part strategy. Let's talk about strategy. We'll want to include physical traits that are commonly associated with specific character types. I'll teach you how to look for and apply these traits in this chapter. We'll focus on three essential areas: the outline of the head, the features, and the hair (which contributes a surprisingly important portion of a character's design).

TEMPLATES FOR THE HEAD

A template is like a map. If you get a little lost, you can check the template, make the adjustments, and stay "on model," which is an animation term for staying true to the proportions of the character.

FRONT VIEW: BASIC TEMPLATE

Let's look at a basic template for a teen's face.

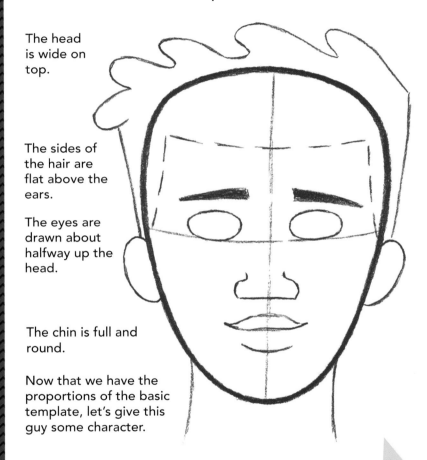

The head is wide on top.

The sides of the hair are flat above the ears.

The eyes are drawn about halfway up the head.

The chin is full and round.

Now that we have the proportions of the basic template, let's give this guy some character.

TEMPLATE

Add big pupils.

Draw the nose and mouth close together.

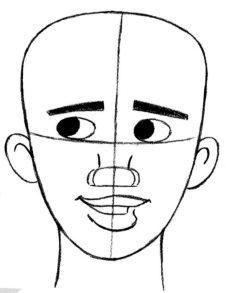

Heavy eyebrows will draw the viewer's attention to the eyes.

Indicate a partial bridge of the nose.

The upper lip peaks in the middle.

TIP
Viewers like to see characters who are smiling with open, rounded eyes.

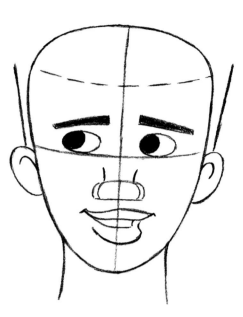

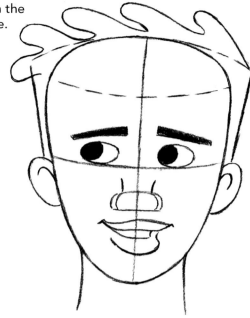

The hair angles out on the sides, which adds style.

The hairline (dotted line) rounds off the forehead.

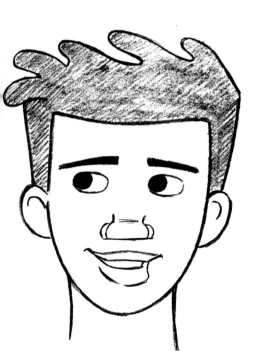

Fill in the hair with sketchy shading.

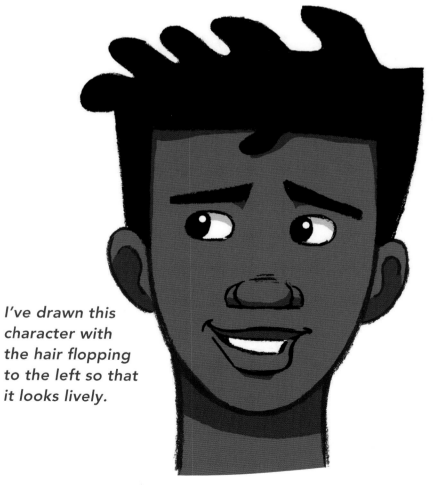

I've drawn this character with the hair flopping to the left so that it looks lively.

SIDE VIEW: BASIC TEMPLATE

I often hear from artists who have trouble repeating a drawing of a character at different angles, such as a side view. A template solves this by keeping the features where they need to be.

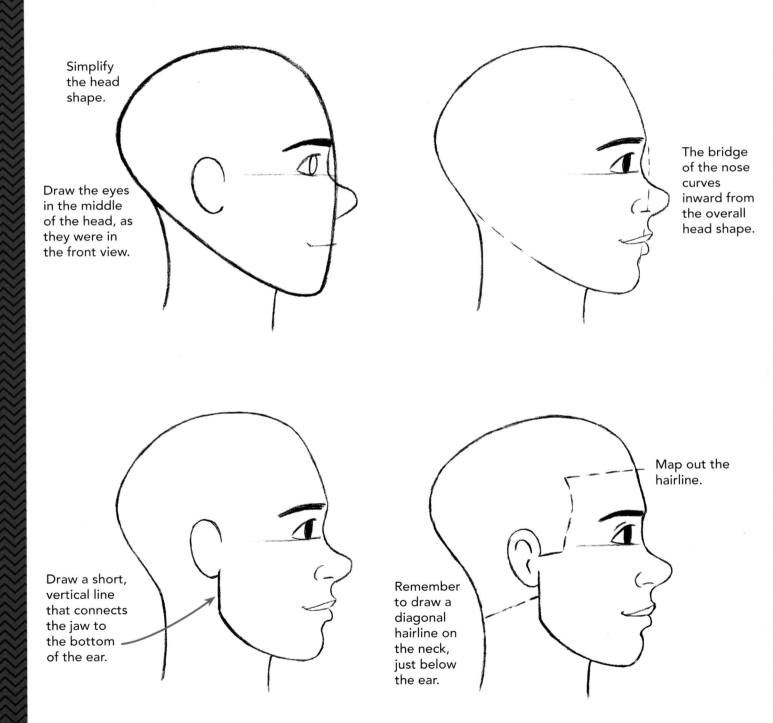

Simplify the head shape.

Draw the eyes in the middle of the head, as they were in the front view.

The bridge of the nose curves inward from the overall head shape.

Draw a short, vertical line that connects the jaw to the bottom of the ear.

Map out the hairline.

Remember to draw a diagonal hairline on the neck, just below the ear.

Using a guideline for the curve of his hair keeps it from looking chaotic.

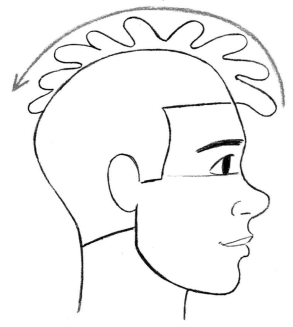

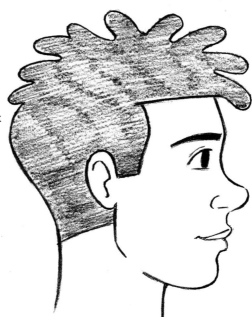

High back of head

Small steps turn a head shape into an appealing character type.

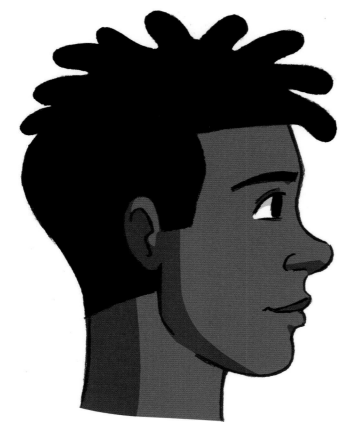

He looks like he's thinking about something. I bet he's wondering, "What are those letters doing in front of my face?"

TEMPLATES FOR THE BODY

Just as a cartoon head can be a "type," a cartoon body can also be a type. Cartoon bodies can be constructed to represent a specific age or attitude. It's important to match the face type with the body type.

ADOLESCENT

Adolescents are an audience favorite in animation. Their proportions are exaggerated, which makes them gawky but endearing. A successful formula is a large head on top of a slender figure. This creates a funny, lopsided look.

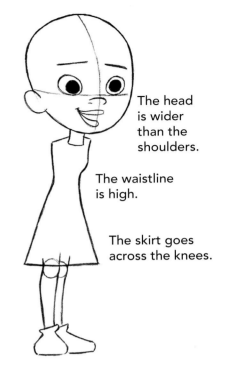

The head is wider than the shoulders.

The waistline is high.

The skirt goes across the knees.

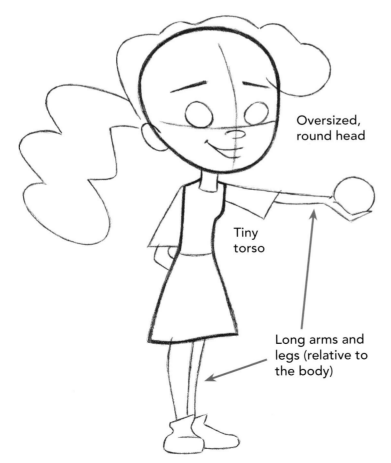

Oversized, round head

Tiny torso

Long arms and legs (relative to the body)

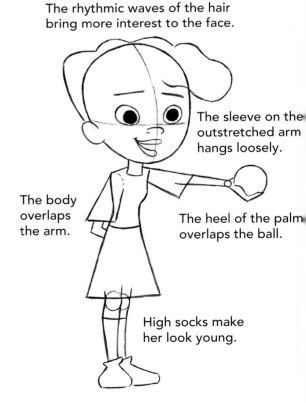

The rhythmic waves of the hair bring more interest to the face.

The sleeve on the outstretched arm hangs loosely.

The body overlaps the arm.

The heel of the palm overlaps the ball.

High socks make her look young.

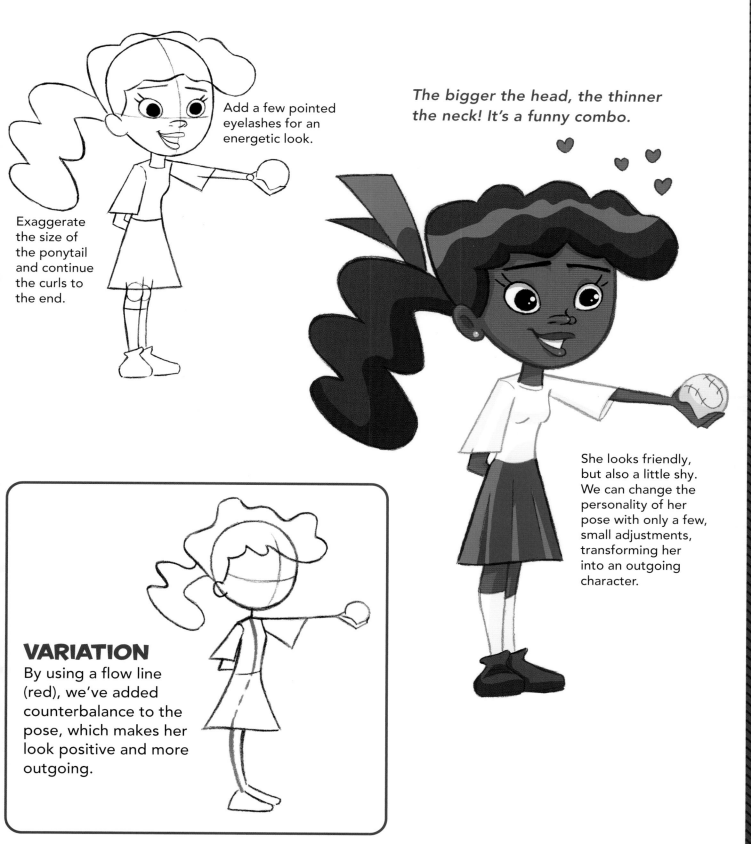

Add a few pointed eyelashes for an energetic look.

Exaggerate the size of the ponytail and continue the curls to the end.

The bigger the head, the thinner the neck! It's a funny combo.

She looks friendly, but also a little shy. We can change the personality of her pose with only a few, small adjustments, transforming her into an outgoing character.

VARIATION

By using a flow line (red), we've added counterbalance to the pose, which makes her look positive and more outgoing.

LITTLE KID

A child character is all about proportions. The head shape is as important a physical trait as the features of the face. The upper head is greatly exaggerated, while the mouth area is diminished. You would think that a child's head construction would be obvious, but here are some hints to make it work.

Extended cheek area

Erase the bottom of the circle so that the outline becomes a single shape.

TIP
On young girl and boy characters, enlarge the pupils greatly. The bigger the better!

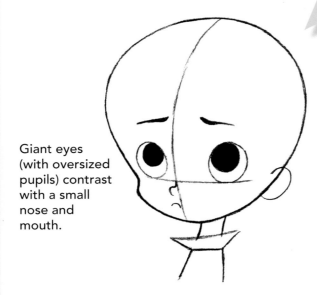

Giant eyes (with oversized pupils) contrast with a small nose and mouth.

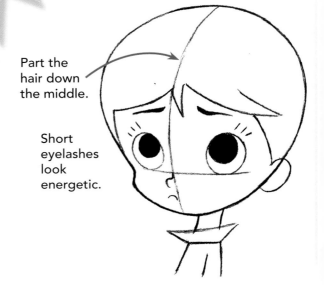

Part the hair down the middle.

Short eyelashes look energetic.

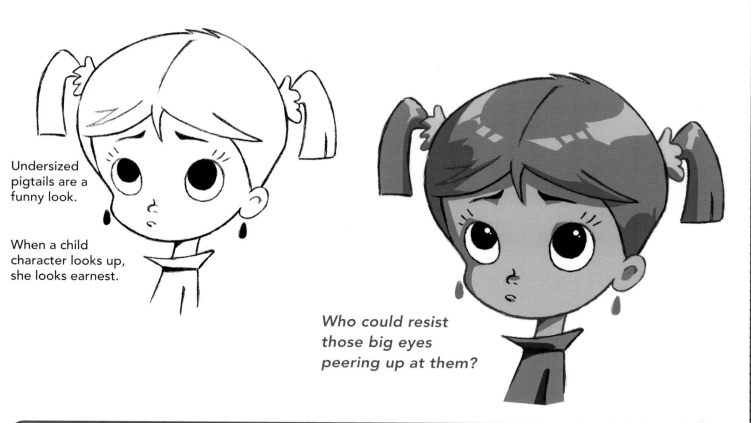

Undersized pigtails are a funny look.

When a child character looks up, she looks earnest.

Who could resist those big eyes peering up at them?

CHANGING PROPORTIONS

Inventing new characters means experimenting with proportions. By changing a proportion, such as where the eyes are placed on the head, you change the look of the character. When you change one proportion, it forces other proportions to change.

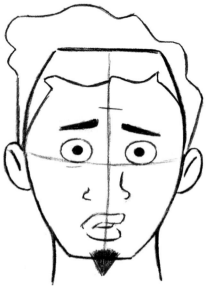

Eyes in Center

On most humans, the eyes are in the middle of the head—and the ears are in the middle, too.

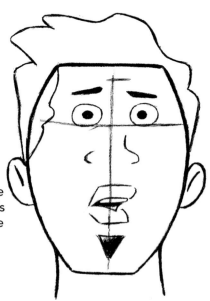

Eyes at Top of Face

Placing the eyes above the middle of the head tends to stretch out the look of the face.

MIDDLE SCHOOLER

This in-between age makes for entertaining characters. Neither children nor teenagers, they're mini adults. The key is to match a simplified head shape with simplified expressions.

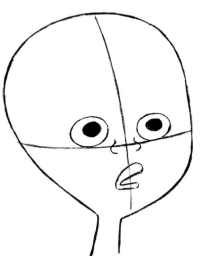

As with all youngsters, the features are close together, which intensifies the expression.

There is a softness to the outline of the face.

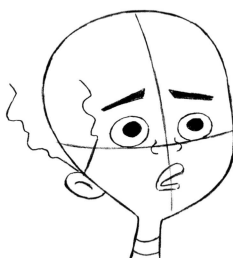

Draw bold, straight eyebrows.

The small, bottom lip doesn't need to do much to create a convincing expression.

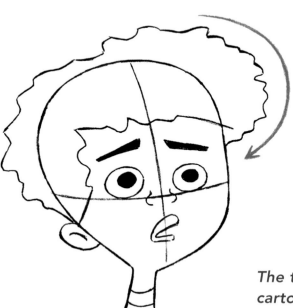

The hair wraps around the head.

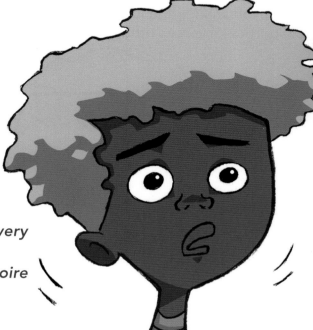

The three words every cartoon character needs in his repertoire are "He did it!"

POPULAR GUY

Popular types have balanced features. But the audience won't remember your character if you don't find something to highlight. Therefore, let's create a block of hair that flops over the eyes.

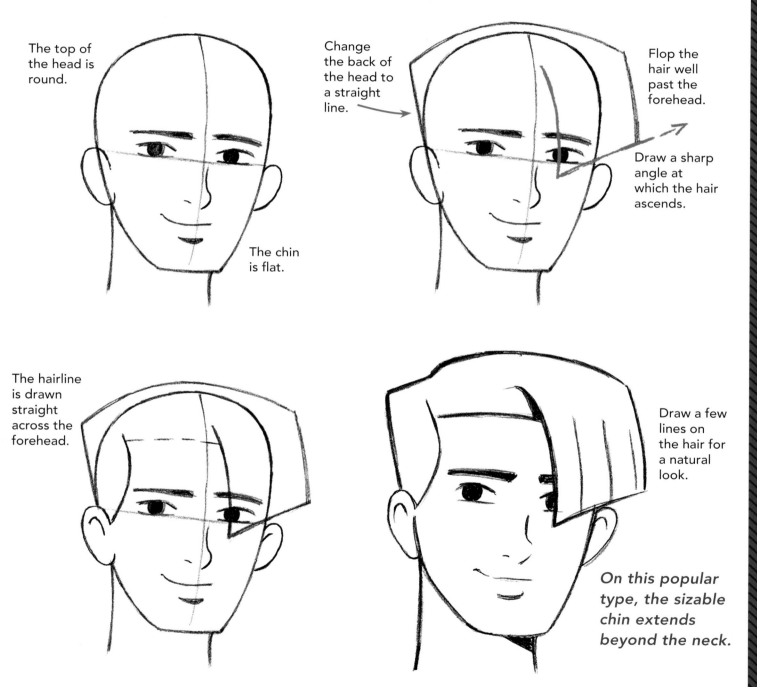

The top of the head is round.

The chin is flat.

Change the back of the head to a straight line.

Flop the hair well past the forehead.

Draw a sharp angle at which the hair ascends.

The hairline is drawn straight across the forehead.

Draw a few lines on the hair for a natural look.

On this popular type, the sizable chin extends beyond the neck.

CHEERFUL GIRL

The typical template for young characters begins by drawing super-wide eyes that are the highlight of the face. You can use this idea to create many appealing, youthful characters. Let's try it out.

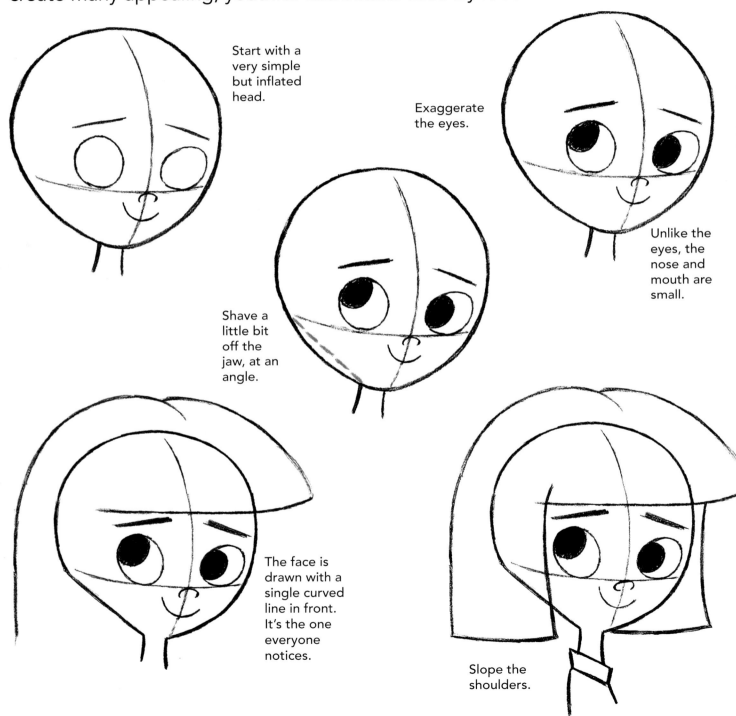

Start with a very simple but inflated head.

Exaggerate the eyes.

Unlike the eyes, the nose and mouth are small.

Shave a little bit off the jaw, at an angle.

The face is drawn with a single curved line in front. It's the one everyone notices.

Slope the shoulders.

With a head that big, she must have a big brain!

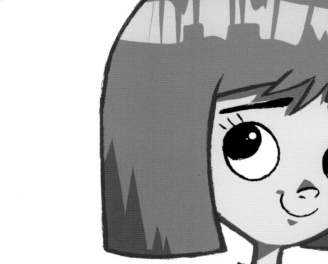

The bottom of the hair on the left and on the right are drawn at the same level.

TIP
Typically, small characters are drawn with heads that are much larger than their bodies.

23

CHARACTERS WITH ATTITUDE

Sometimes, a character can have a simple head construction but still communicate a lot of attitude through the eyes. Let's see how.

CLOSED EYES

This character oozes confidence, and shows that the eyes don't even have to be open to be expressive.

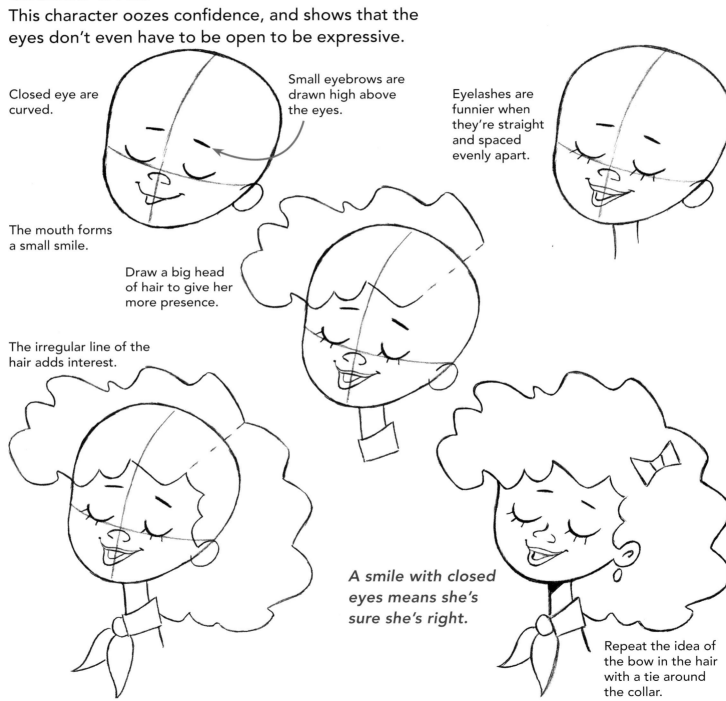

Closed eye are curved.

Small eyebrows are drawn high above the eyes.

Eyelashes are funnier when they're straight and spaced evenly apart.

The mouth forms a small smile.

Draw a big head of hair to give her more presence.

The irregular line of the hair adds interest.

A smile with closed eyes means she's sure she's right.

Repeat the idea of the bow in the hair with a tie around the collar.

OPEN EYES

Young characters typically have heads that are wide on top. This little guy's eyes look upward, giving him an innocent look.

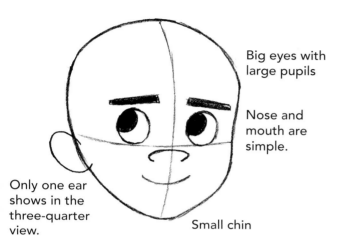

Big eyes with large pupils

Nose and mouth are simple.

Only one ear shows in the three-quarter view.

Small chin

The hair is energetic, and there's a lot of it!

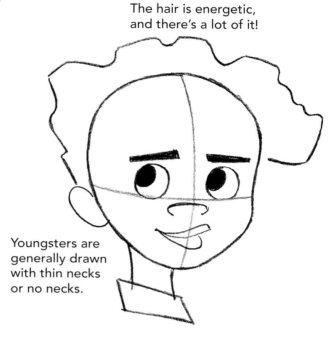

Youngsters are generally drawn with thin necks or no necks.

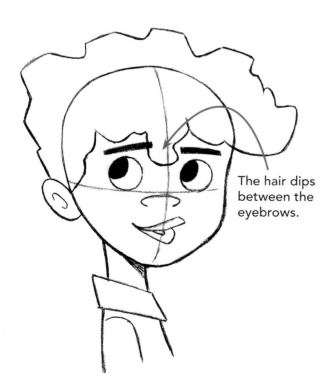

The hair dips between the eyebrows.

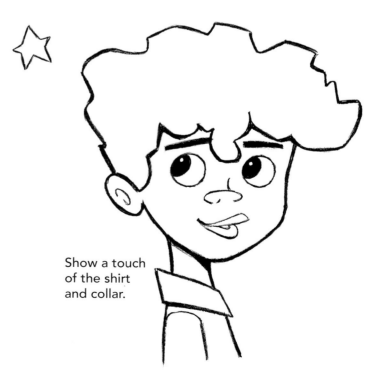

Show a touch of the shirt and collar.

THE CHINLESS WONDER

Most of the time, the physical traits of a character work in harmony. But sometimes, they downright refuse, with funny results. This middle-aged guy's hair can't decide where the part should go or if there even is a part. His nose has been designed after an awning. And his chin is somewhere in the Lost & Found.

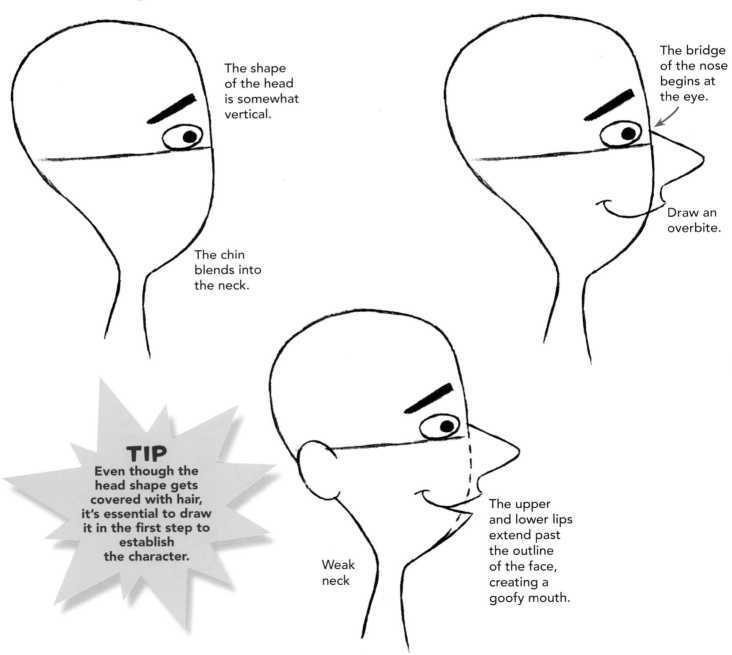

The shape of the head is somewhat vertical.

The chin blends into the neck.

The bridge of the nose begins at the eye.

Draw an overbite.

TIP
Even though the head shape gets covered with hair, it's essential to draw it in the first step to establish the character.

Weak neck

The upper and lower lips extend past the outline of the face, creating a goofy mouth.

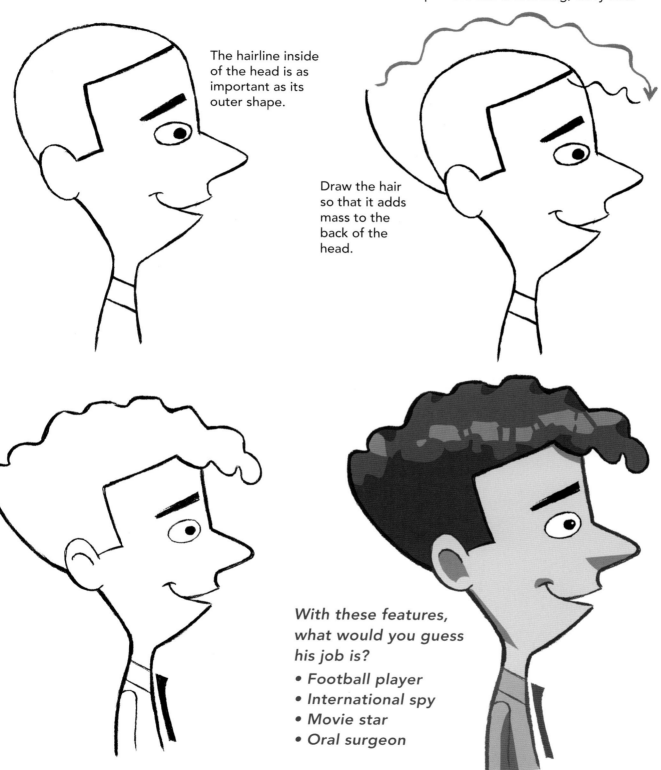

The hairline inside of the head is as important as its outer shape.

The top of the hair is one long, wavy line.

Draw the hair so that it adds mass to the back of the head.

With these features, what would you guess his job is?

- *Football player*
- *International spy*
- *Movie star*
- *Oral surgeon*

27

GENRE CHARACTERS

Characters from cartoon genres employ accessories, special effects, costumes, and hairstyles to establish their type.

TEEN ZOMBIE

By choosing the right elements, you can transform the template of an ordinary teenager into anything, even a zombie.

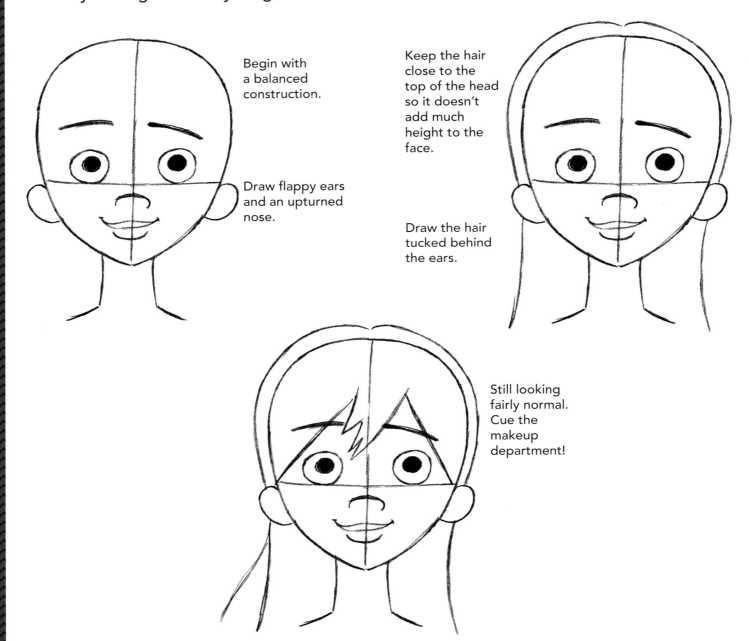

Begin with a balanced construction.

Draw flappy ears and an upturned nose.

Keep the hair close to the top of the head so it doesn't add much height to the face.

Draw the hair tucked behind the ears.

Still looking fairly normal. Cue the makeup department!

Yikes! Let's count up the effects that have been added:

1. Stiff eyelashes (yes, that's an effect, too)
2. Scar
3. Skull as a hair accessory
4. The most important effect is the subtlest: black rings under the eyes.

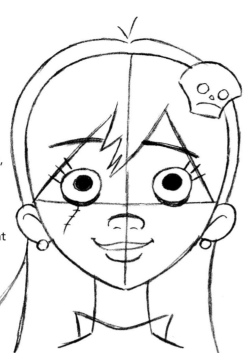

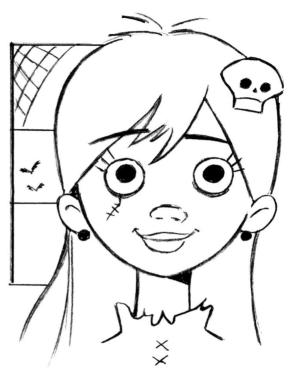

This isn't your average neighbor. And that isn't a cup of sugar she's coming to borrow.

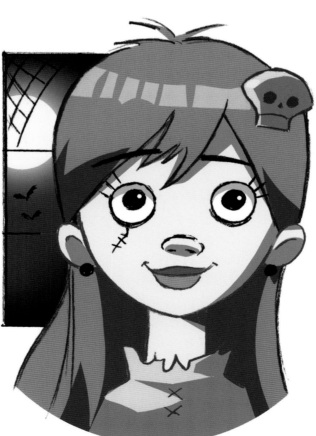

29

A BOY AND HIS MONSTER

In animated movies, characters often find friendships with unlikely types. For example, the kid looks normal, but the creature does not. How will the kid resume his life with this thing tagging along? Solution: Make the monster invisible so that only the kid can see it.

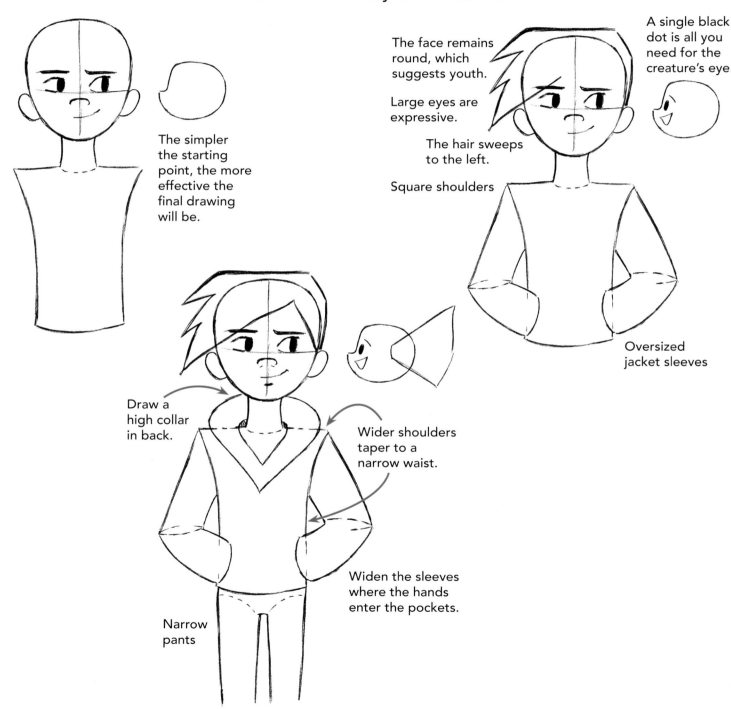

The simpler the starting point, the more effective the final drawing will be.

The face remains round, which suggests youth.

Large eyes are expressive.

The hair sweeps to the left.

Square shoulders

A single black dot is all you need for the creature's eye

Oversized jacket sleeves

Draw a high collar in back.

Wider shoulders taper to a narrow waist.

Widen the sleeves where the hands enter the pockets.

Narrow pants

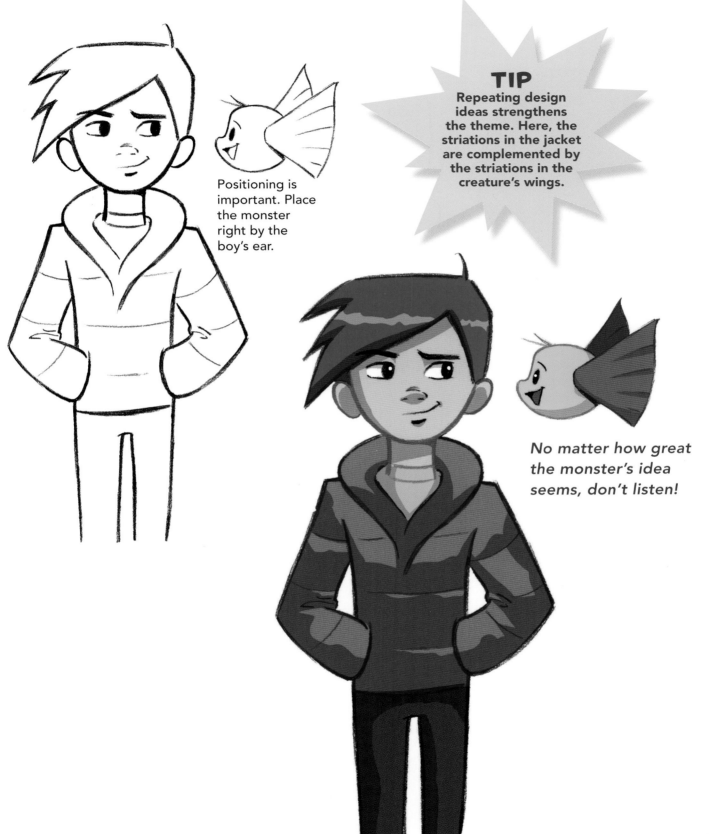

Positioning is important. Place the monster right by the boy's ear.

TIP
Repeating design ideas strengthens the theme. Here, the striations in the jacket are complemented by the striations in the creature's wings.

No matter how great the monster's idea seems, don't listen!

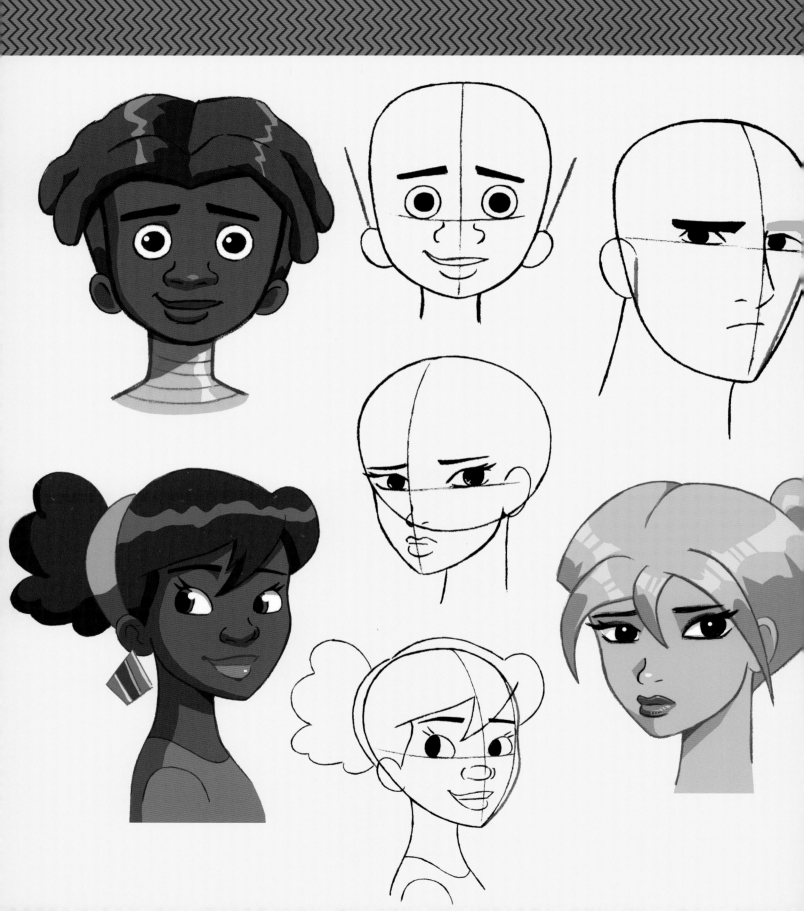

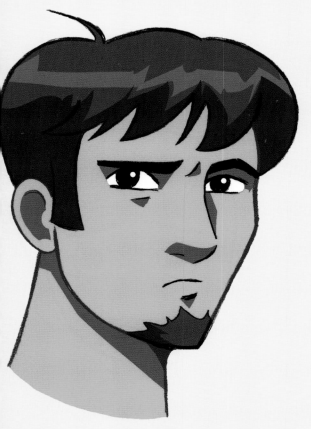

MODIFYING YOUR CHARACTERS

Don't stop at your first attempt at a drawing. There may be a better way to draw it, and it only takes a few changes to find it. The variations in this chapter will give you insights into the possibilities, which you can use in your own artwork. Ready to give it a try? We'll go step by step.

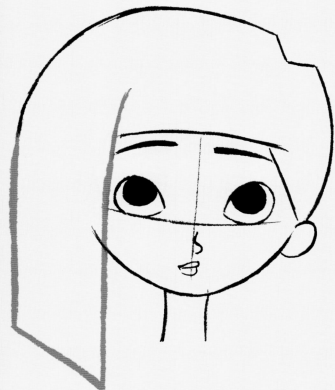

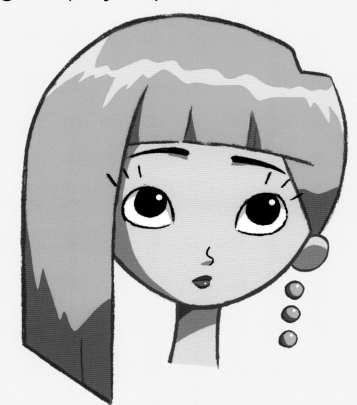

CHANGING SHAPES

How do you know what to modify? By experimenting! Look for an intuitive feeling that a drawing needs something. Start with small changes. Here's a tip: It's easier to modify a character if you begin with the shape of the head. That's where we'll put our focus.

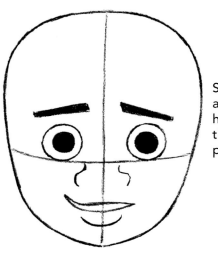

Start with a wide and balanced head and eyes that are almost perfectly round.

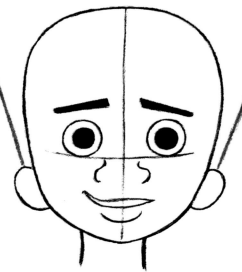

Modify the head so that it widens out. We've left the original shape of the head behind and are creating something new—with only two lines!

TIP
A round head is predictable. By flattening the sides, you add a fresh approach.

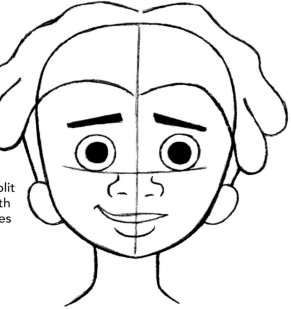

Although the hair appears to flop in a random manner, it's quite symmetrical: split down the middle, with the left and right sides evenly weighted.

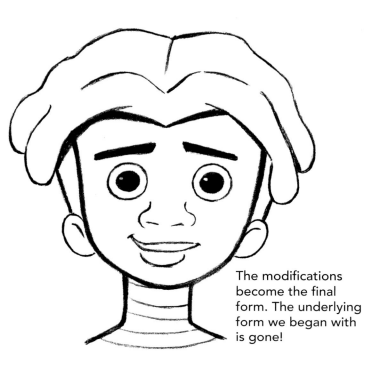

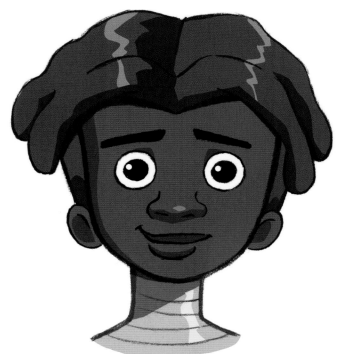

The modifications become the final form. The underlying form we began with is gone!

SHAPE SHIFTING

You don't need to change all aspects of a character to create a new design. Just making one modification can change the whole look.

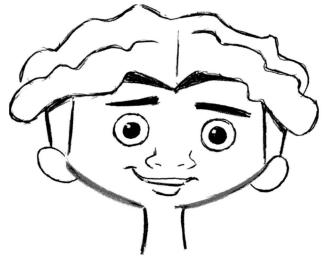

Making the face shorter and wider gives him a younger look.

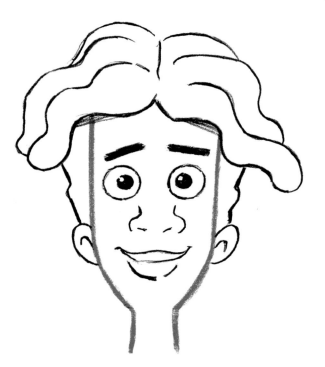

Narrowing the face makes him look older and a little goofy.

35

CREATING ANGLES

To create a dramatic character, there's no better way than to add dramatic angles. The sharper the angle, the more intense the character will be. It only takes one or two changes to make a big difference. Follow along or improvise!

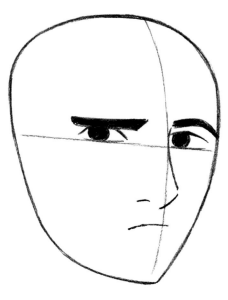

In this three-quarter view (the character is turned slightly to the right), the far edge of the face is fairly straight while the near side is rounded.

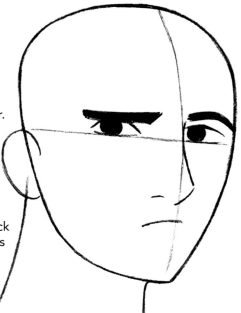

Heavy eyebrows contribute to a dramatic character.

Before we make any modifications, let's give him a thick neck, which creates a sturdy look.

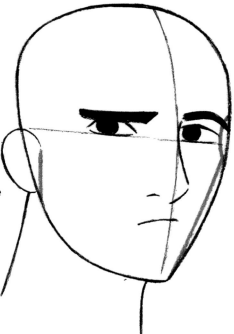

Rather than changing everything, let's try to bring out the character with an economy of linework.

Draw a short vertical line from the top of the ear to the point of the jaw.

Scoop out a curve at the far side of the eye. This modification is typical in turned angles, even on realistically drawn people.

Slash a straight line from the top of the cheekbone to the tip of the chin for a dramatic look.

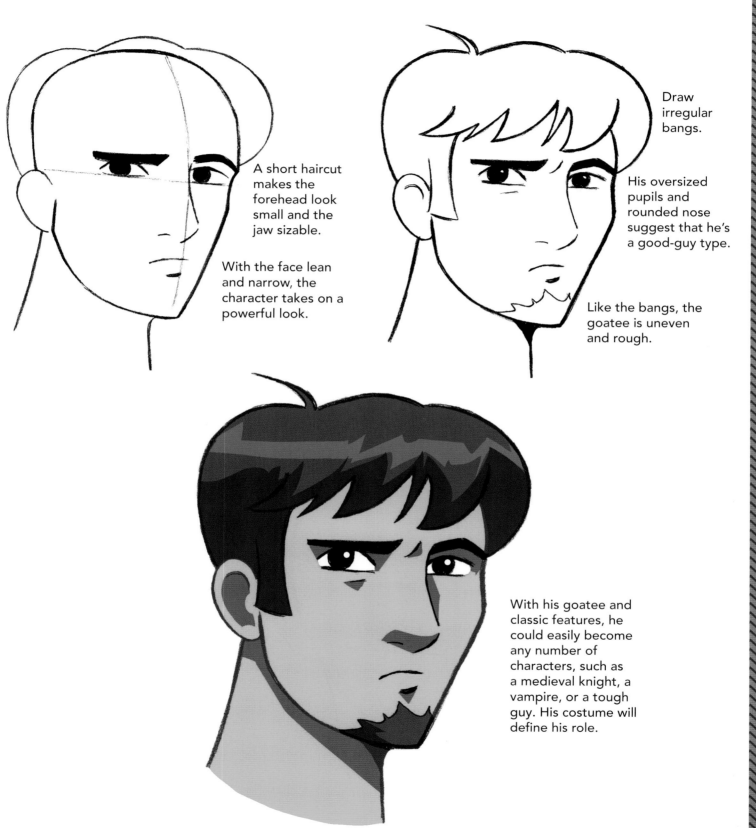

A short haircut makes the forehead look small and the jaw sizable.

With the face lean and narrow, the character takes on a powerful look.

Draw irregular bangs.

His oversized pupils and rounded nose suggest that he's a good-guy type.

Like the bangs, the goatee is uneven and rough.

With his goatee and classic features, he could easily become any number of characters, such as a medieval knight, a vampire, or a tough guy. His costume will define his role.

FLAT PLANES

Sometimes, flattening a curve is just the thing to give a drawing a stylish look. But this approach can be abrupt, and therefore needs something to soften the look. And that's exactly what we're going to do with this hairstyle.

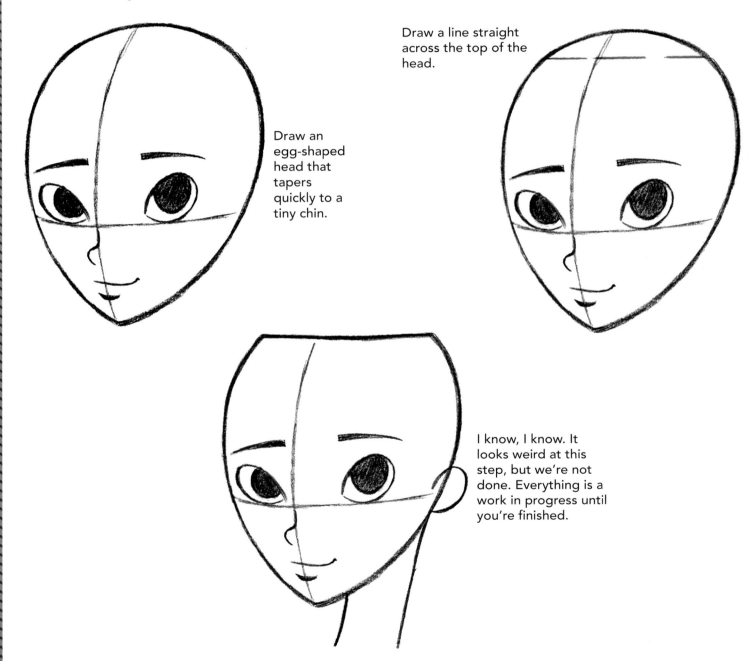

Draw an egg-shaped head that tapers quickly to a tiny chin.

Draw a line straight across the top of the head.

I know, I know. It looks weird at this step, but we're not done. Everything is a work in progress until you're finished.

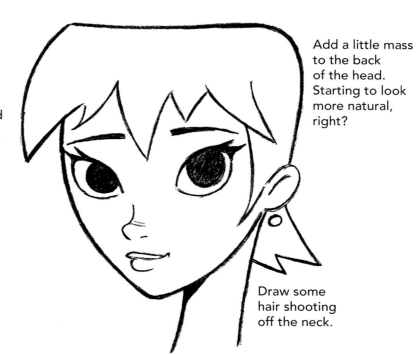

Lively bangs, which extend past the forehead, soften the construction.

Add a little mass to the back of the head. Starting to look more natural, right?

Draw some hair shooting off the neck.

TIP
When one area of a character is flat, counterbalance it with another area that's curved, like the line that runs down the front of her face.

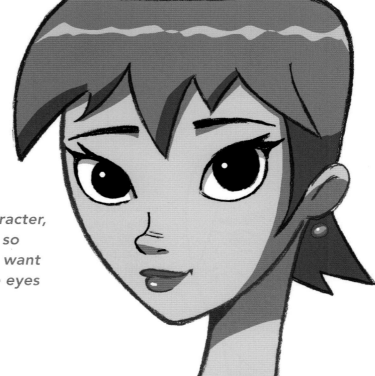

With a stylish character, color is strategic, so decide which you want to stand out—the eyes or the hairstyle.

CREATING TWO PLANES

Now we'll add a second plane to the outline of a character's face. Interestingly, when you create two planes, they tend to cancel each other out, so the result is less extreme and more balanced than a character with only one pronounced plane.

TIP
By drawing a flat top and a flat chin, you bookend the face.

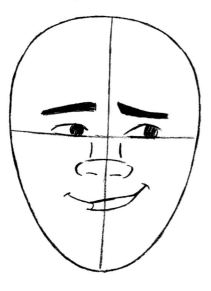

Start with a generic outline of the head, with the features in the center. Be careful not to crowd them.

Lop off the top and bottom of the head.

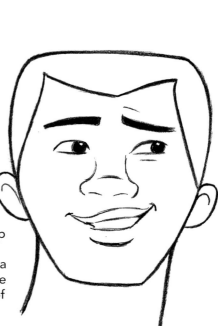

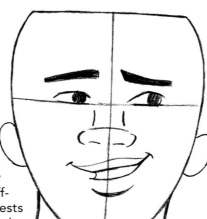

I often like to draw the neck slightly off-center, which suggests movement or attitude.

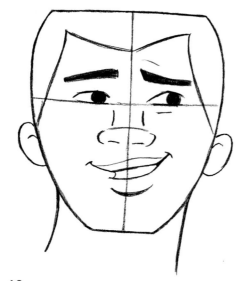

Instead of building more hair on top of the head, allow the hair to dip at the center of the forehead.

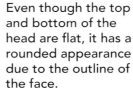

Even though the top and bottom of the head are flat, it has a rounded appearance due to the outline of the face.

SOFTENING THE CONTOURS

We've been creating dramatic changes to the heads by using straight lines. But modifications can also be used to enhance the curves of the face, which will make the character more lifelike. This creates a pleasing effect, which is attractive, friendly, and engaging.

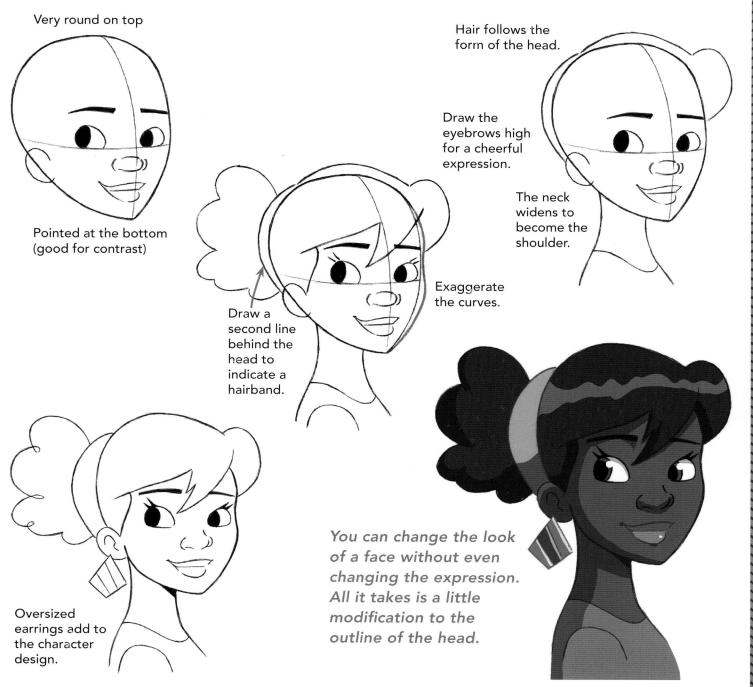

Very round on top

Pointed at the bottom (good for contrast)

Draw a second line behind the head to indicate a hairband.

Hair follows the form of the head.

Draw the eyebrows high for a cheerful expression.

The neck widens to become the shoulder.

Exaggerate the curves.

Oversized earrings add to the character design.

You can change the look of a face without even changing the expression. All it takes is a little modification to the outline of the head.

41

EXAGGERATED CURVES

We tend to think that the body has all the curves. But the face, especially on young characters, has curves that are even more pronounced. Curves are both outward (convex) and inward (concave). This combination creates a charming personality—and a popular character type.

The head starts out like a beach ball that's losing air.

Giant pupils make her look startled.

Place the nose at the bottom of the face, at the intersection of the guidelines.

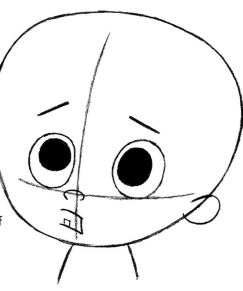

Draw an exaggerated curved line that dips in the middle. This highlights the cheek area.

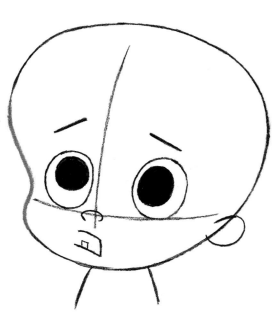

The curved line at the front of the face makes the forehead look bigger.

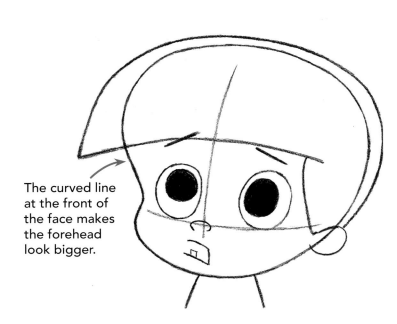

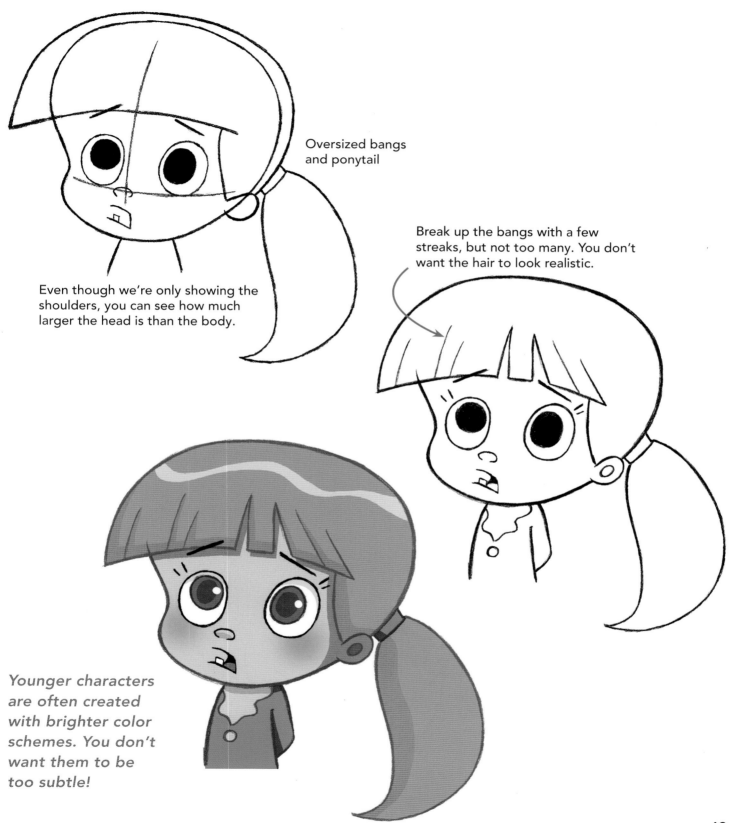

Oversized bangs and ponytail

Even though we're only showing the shoulders, you can see how much larger the head is than the body.

Break up the bangs with a few streaks, but not too many. You don't want the hair to look realistic.

Younger characters are often created with brighter color schemes. You don't want them to be too subtle!

43

COMPOUND SHAPES

Here's a useful shortcut you can use for your character designs. Instead of making modifications to the entire head, draw the head in two parts. Maintain the shape of the top of the head, and make your modifications to the bottom half—or vice versa.

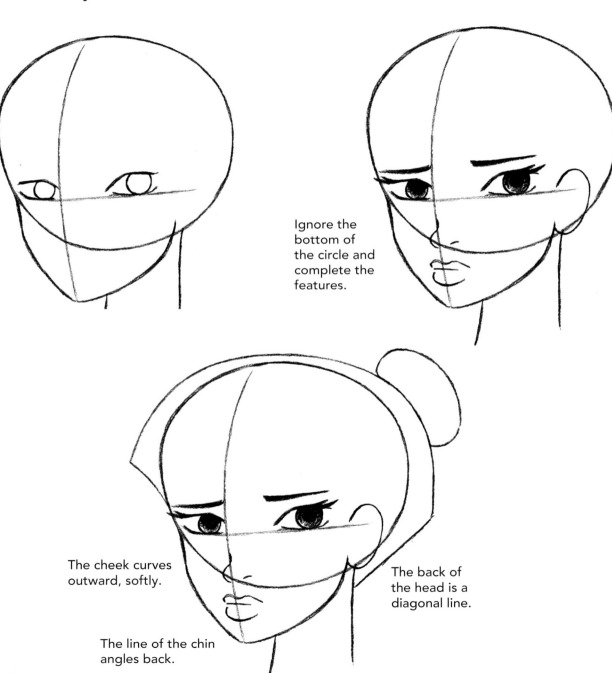

Beginning with a circle is easier than drawing an unusual shape from scratch.

Draw the lower part of the face, which contains the mouth, jaw, and chin.

Ignore the bottom of the circle and complete the features.

The cheek curves outward, softly.

The back of the head is a diagonal line.

The line of the chin angles back.

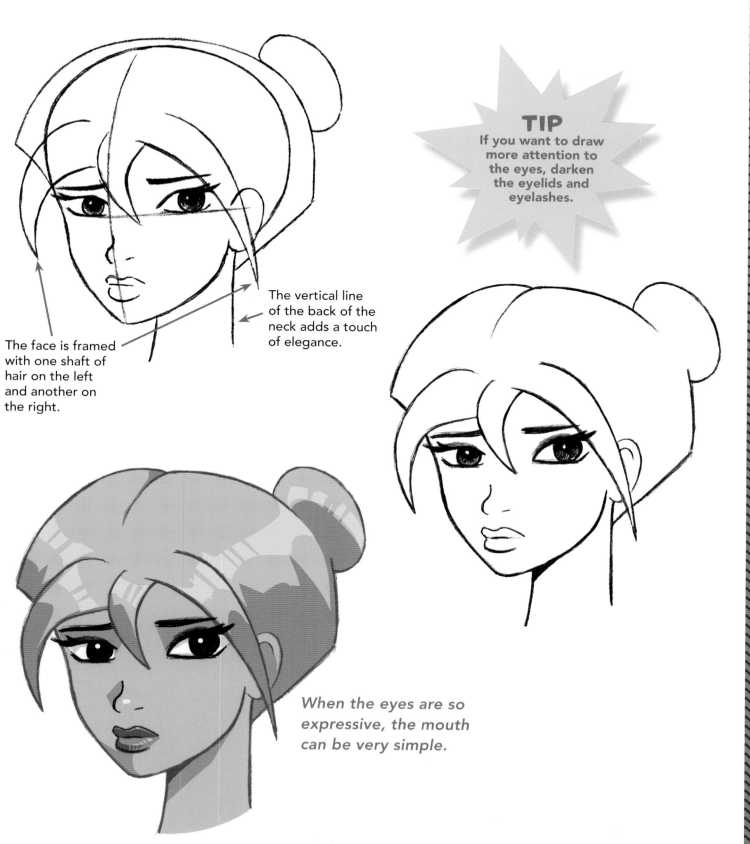

TIP
If you want to draw more attention to the eyes, darken the eyelids and eyelashes.

The vertical line of the back of the neck adds a touch of elegance.

The face is framed with one shaft of hair on the left and another on the right.

When the eyes are so expressive, the mouth can be very simple.

45

CREATING A POINT OF EMPHASIS

If you draw everything with equal intensity, nothing will have impact. To make something stand out, you need to place the emphasis in just one area. This simple concept makes a big difference in the appeal factor of your characters.

THE EYES

The eyes are an obvious choice for emphasis, because they're central to the look of any face. Let's see if we can increase the appeal by placing special emphasis on them.

No Emphasis
This character has an attractive face with no particular emphasis. The eyes, lips, and hair have been drawn with equal intensity. The face is harmonious but a little quiet.

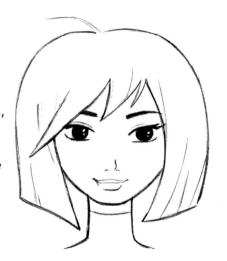

Emphasis
We increased the size of the pupils. This small change makes a big difference. Also, the eyebrows are now visible through the hair.

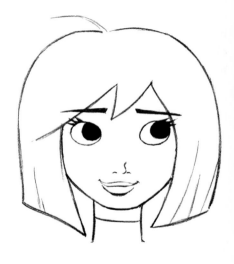

No Emphasis
The eyes are small and barely fill up the face. Let's increase their size and see what happens.

Emphasis
Large, round eyes communicate. They make you wonder what the character is thinking.

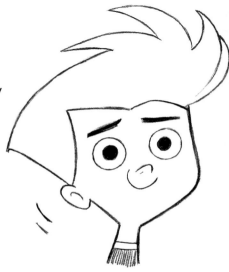

THE NOSE

For many artists, the first choice for creating a funny character is the nose. It can be exaggerated in a variety of ways. The best approach is to integrate this feature into the overall design of the face.

Exaggerated Nose #1

By exaggerating the nose, you can create a unique individual, even if the rest of the character's features are balanced.

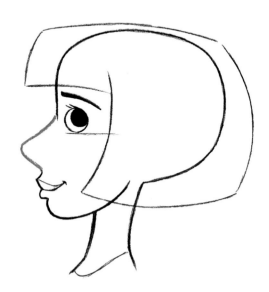

Exaggerated Nose #2

This nose creates a more extreme design but is still integrated into the construction of the head.

A long, sloping line connects the bridge of the nose to the top of the head.

Counterbalance the protruding nose with a receding chin. It's simple but effective.

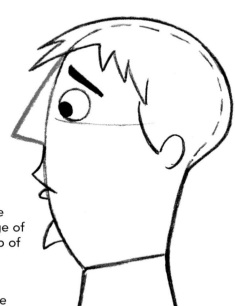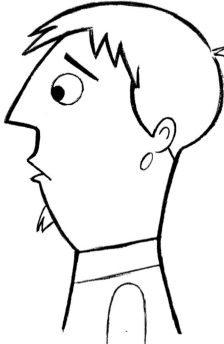

THE FOREHEAD

We can also exaggerate various aspects of the head itself in order to develop a character type. Let's look at how the forehead can really define a character.

The hair is combed flat across the top of his head.

Big Forehead

This computer geek's massive forehead towers over his tiny eyes and nose. The hair softens the rectangular shape of the forehead, but can't hide it.

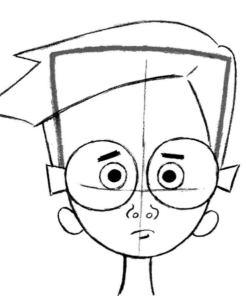

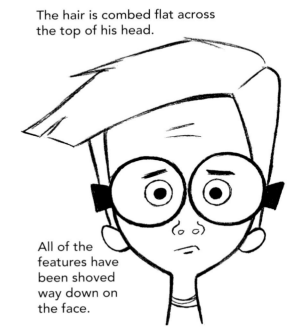

All of the features have been shoved way down on the face.

Small Forehead

Sometimes we de-emphasize something in order to make it stand out. I've drawn a simplified cranium for this fellow. And to drive the point home, I've elongated the chin so that the skull looks even smaller.

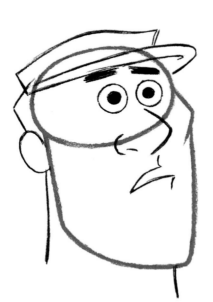

The small forehead forces us to draw the eyes close together, creating a unique look.

THE CHIN

The chin is undervalued as a primary tool for character design. Enlarge it or reduce it and you're halfway to a new character. The chin has the unique ability to enhance an expression and personality type.

Square Jaw
When you exaggerate the construction of the head, you don't have to rely so much on the features.

Reduce the size of the forehead. You don't want the forehead and chin to balance each other out. Allow the length of the chin to dominate.

For this character to work, draw the mouth about a mile and a half from the bottom of the chin.

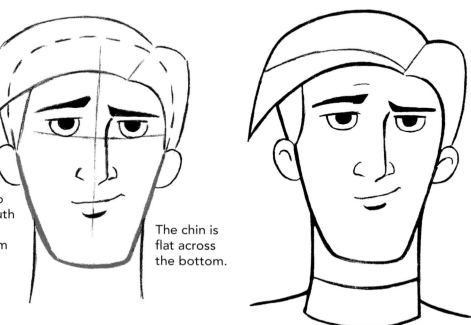

The chin is flat across the bottom.

Long Chin
This chin is the shape of a football, which makes him look goofy. Notice that there are no defining features on the chin, such as a beard or facial creases. Let the chin stand out all by itself.

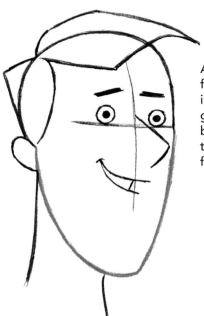

All of the features, including the glasses, have been shifted to the top of the face.

49

ACCESSORIES AND HAIR

Perhaps you've created a character that doesn't require exaggeration. No problem. But maybe it could still use a few things to jazz it up. You could leave the character's basic construction intact and adjust external items such as accessories and hair.

ACCESSORIES

Earrings, necklaces, and hair accessories are easy ways to dress up a character and give them a unique look. In cartoons, the bigger the better!

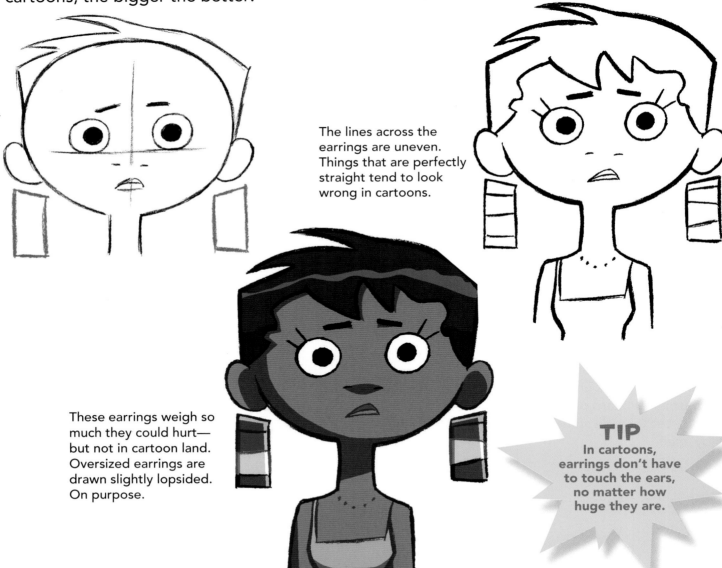

The lines across the earrings are uneven. Things that are perfectly straight tend to look wrong in cartoons.

These earrings weigh so much they could hurt—but not in cartoon land. Oversized earrings are drawn slightly lopsided. On purpose.

TIP
In cartoons, earrings don't have to touch the ears, no matter how huge they are.

HAIR

A sharp hairstyle can create an eye-catching visual identity. You could spend a lot of time trying to create one by restyling the bangs, sides, back, and bottom. That's a lot of work. Or, you could take a fairly ordinary style, and by exaggerating just one area, make it extreme.

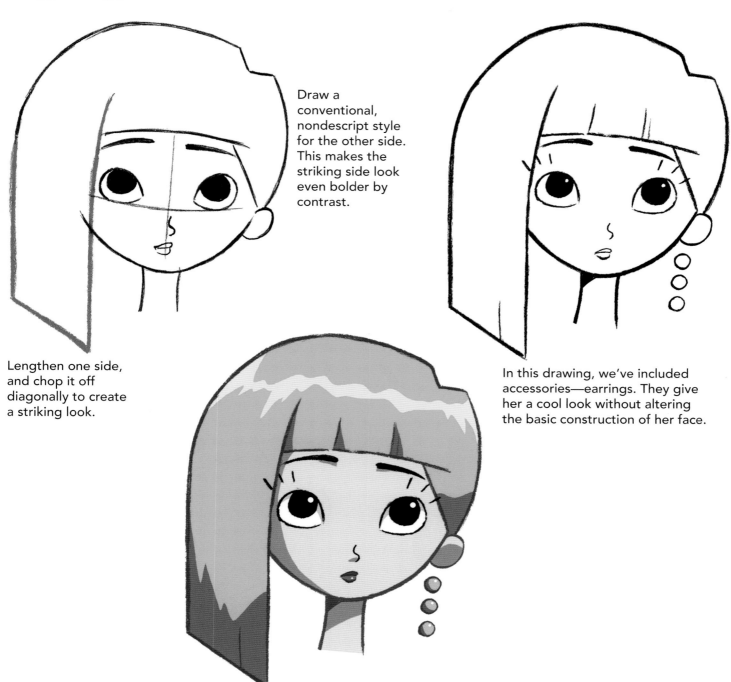

Draw a conventional, nondescript style for the other side. This makes the striking side look even bolder by contrast.

Lengthen one side, and chop it off diagonally to create a striking look.

In this drawing, we've included accessories—earrings. They give her a cool look without altering the basic construction of her face.

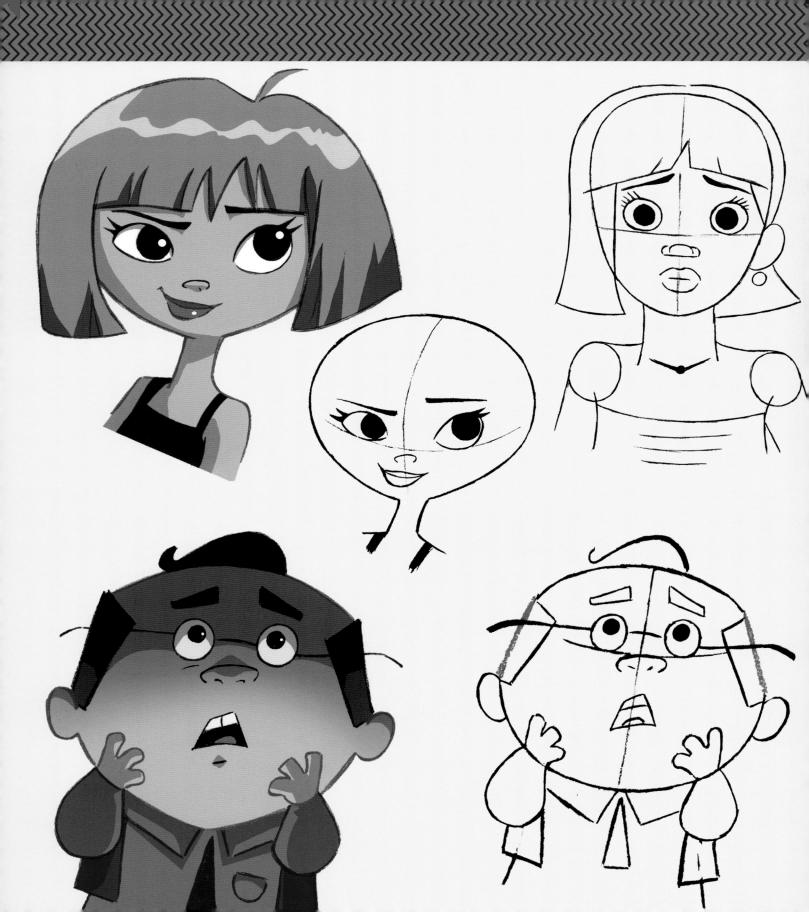

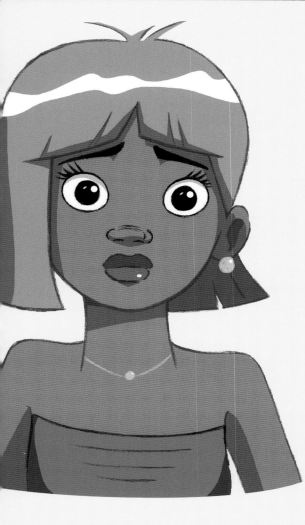

THE NINE CARTOON PERSONALITY TYPES

In this chapter, we'll draw some of the most recognizable character types in cartoons. The nine basic cartoon personality types are popular and enduring. Audiences love them because they're fun and relatable. You can draw them just as they are in this chapter, or combine them to design new types and variations. They each have their own proportions, features, and expressions, which give them a unique look. Let's try a few—or all of them.

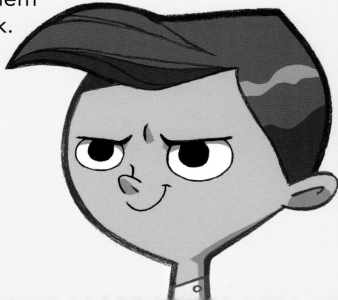

Character Type #1
THE UNLIKELY HERO

This affable character may not have huge muscles and a cape, but that's why people relate to him. He's just like you and me. When he gets into trouble, we worry if he'll escape—all he has are his wits. But somehow, he manages, just in time for the sequel!

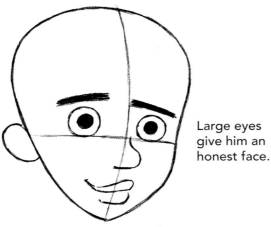

Large eyes give him an honest face.

He's your average everyday guy, but with an uncommon amount of resilience and determination.

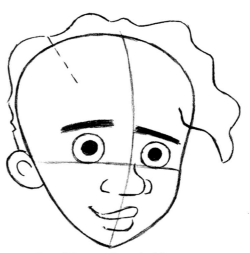

Small but pointed chin

Most beginners only create an indentation on top of the part. But it's more effective if you create a second indentation at the bottom.

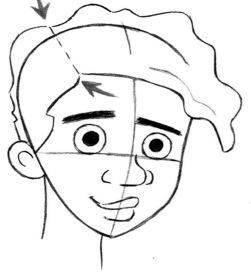

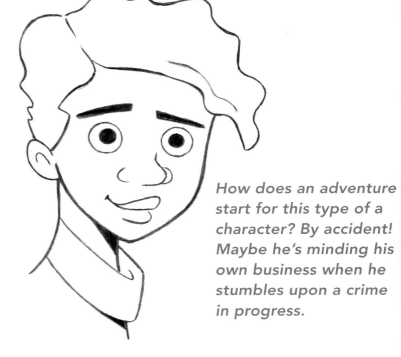

How does an adventure start for this type of a character? By accident! Maybe he's minding his own business when he stumbles upon a crime in progress.

Character Type #2
VILLAIN TYPE A (CON ARTIST)

The mistake some cartoonists make is drawing a villain to look too evil. Instead, let's create a devious type, which is also funny. For example, this guy is so insincere that even his dog doesn't trust him.

Draw the eyelids touching the pupils.

Upturned nose (omit the bridge)

Omit the chin, which gives his head a lopsided look.

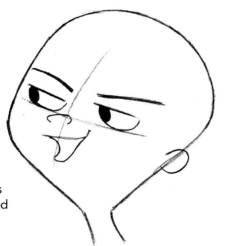

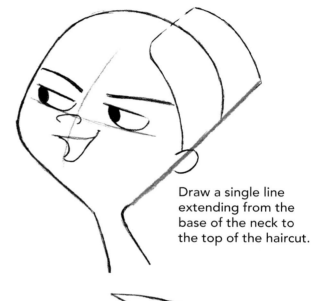

Draw a single line extending from the base of the neck to the top of the haircut.

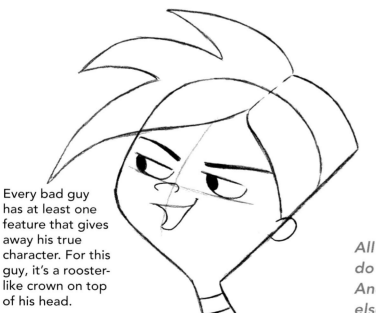

Every bad guy has at least one feature that gives away his true character. For this guy, it's a rooster-like crown on top of his head.

All he wants is to do well in school. And for everyone else to fail.

55

Character Type #3
VILLAIN TYPE B (WICKEDLY EVIL)

Whereas Villain Type A wants to swipe your school lunch, Villain Type B wants to take over the world. After all, if you're going to be evil, you might as well get more out of it than Yankee bean soup.

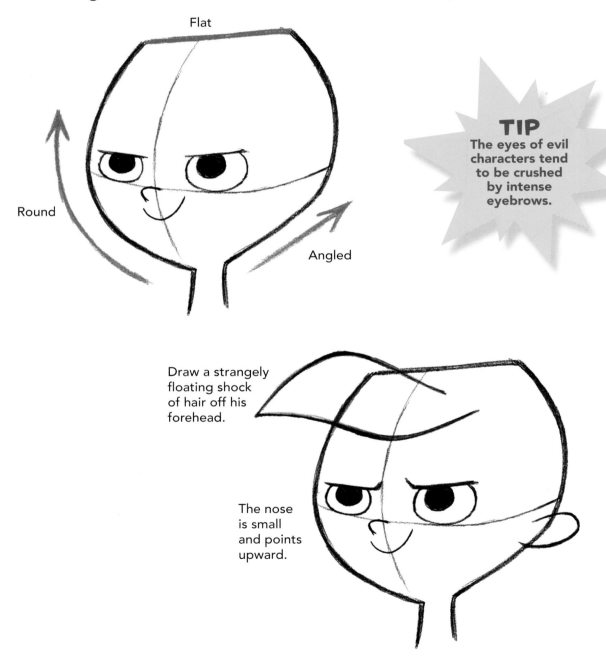

Flat

Round

Angled

TIP
The eyes of evil characters tend to be crushed by intense eyebrows.

Draw a strangely floating shock of hair off his forehead.

The nose is small and points upward.

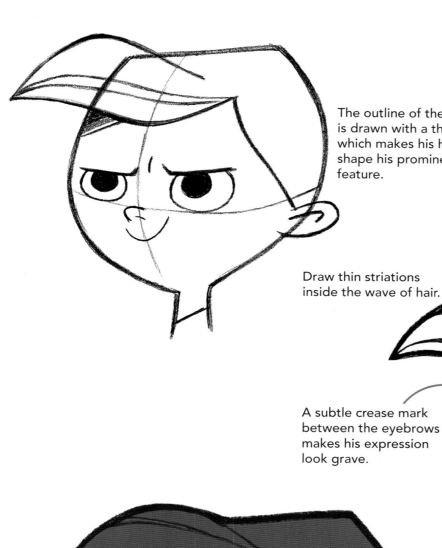

The outline of the head is drawn with a thick line, which makes his head shape his prominent feature.

Draw thin striations inside the wave of hair.

A subtle crease mark between the eyebrows makes his expression look grave.

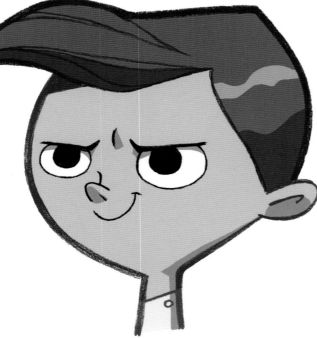

No one knows why he wants to take over the world. I'm not sure he knows. But you've got to give him credit for motivation. Thank goodness he's really, really bad at it.

Character Type #4
AMATEUR DETECTIVE

She's a natural cynic and takes nothing at face value. If she smells trouble, she's on the case. There's always the element of danger—that's "danger" with a small "d."

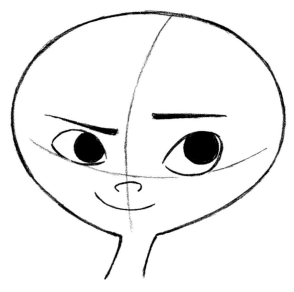

Her head is round and wide.

Draw one eyebrow up and one eyebrow down.

Oversized pupils dominate the eyes.

Draw an upturned nose.

TIP
This look is all about the uneven eyebrows. It's an important expression in your cartooning repertoire.

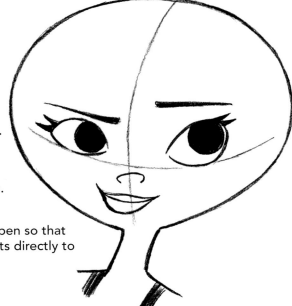

Draw two sharp eyelashes at the edge of each eye.

A small mouth offsets huge eyes.

Leave the chin open so that the head connects directly to the neck.

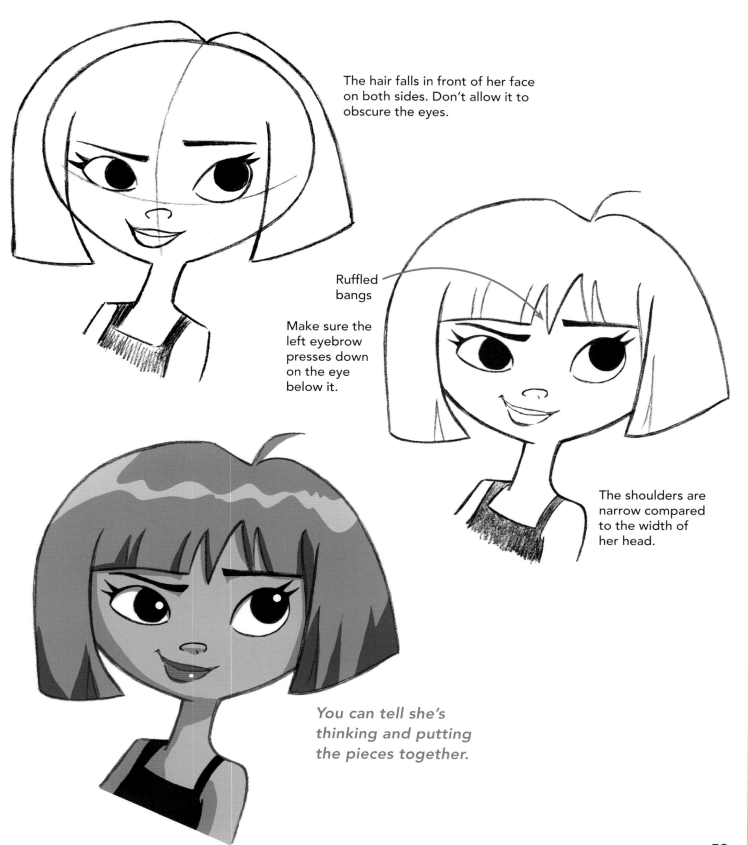

The hair falls in front of her face on both sides. Don't allow it to obscure the eyes.

Ruffled bangs

Make sure the left eyebrow presses down on the eye below it.

The shoulders are narrow compared to the width of her head.

You can tell she's thinking and putting the pieces together.

Character Type #5
DAYDREAMER

This whimsical character follows her muse wherever it takes her. She's dreamy, inventive, and inspired. Her strength is that she can focus on five things at the same time. Her weakness is that she can't focus on just one!

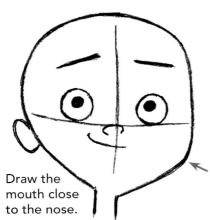

Draw high eyebrows to indicate an idea is forming!

Draw small eyeballs wide apart.

The cheek pushes outward.

Draw the mouth close to the nose.

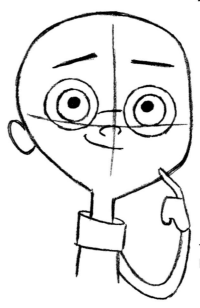

Glasses are a good idea, but focus on the small pupils for an energetic look.

The arm is loose like spaghetti!

Slightly wild hair

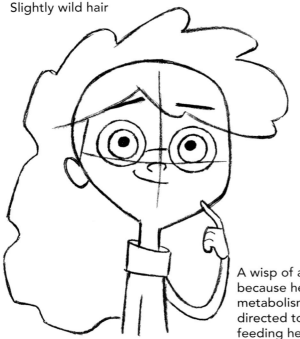

Interesting ideas float past her, and only she can see them!

A wisp of a body because her metabolism is directed toward feeding her brain.

Her hair looks restless because she's distracted by thoughts galore.

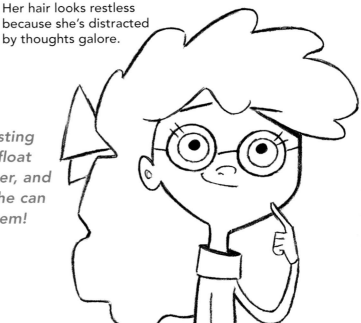

Character Type #6
SHORT FUSE

This personality type overreacts to the slightest offense. Keenly aware that he has a temper problem, he tries hard to hold it in, but it explodes at the most inopportune times.

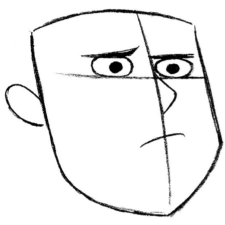

First, let's establish the dimensions:
- Small cranium
- Big chin
- Back of head flat

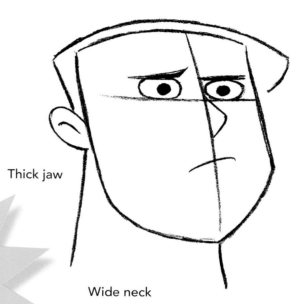

Thick jaw

Wide neck

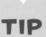

TIP
In order to show that he's basically an okay guy, his face is padded instead of angular.

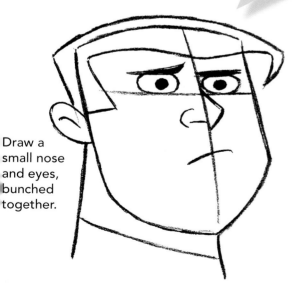

Draw a small nose and eyes, bunched together.

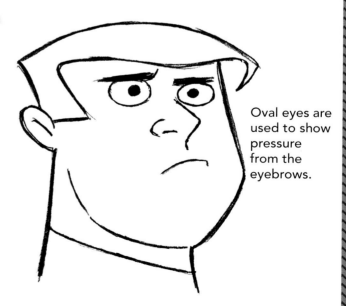

Oval eyes are used to show pressure from the eyebrows.

61

Character Type #7
INDECISIVE

This funny character type freezes anytime an urgent decision is needed. If she's ordering ice cream, she can't decide between chocolate and strawberry. The people in line behind her really love that.

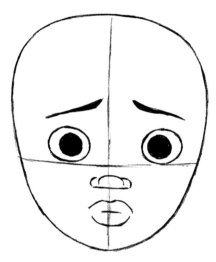

This is the classic suspenseful expression:
- Wide eyes, with pupils in the center
- Eyebrows that lift in the middle of the forehead
- Pursed lips

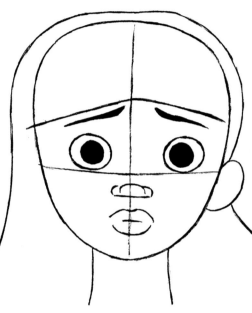

It's tempting to draw frayed hair to reflect her agitated mood. But it works better if the hair is controlled. That focuses the viewer's attention on her expression.

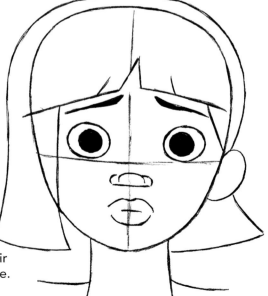

A short line between the upper and lower lips is all you need.

The left side of her hair falls in front of the face.

Kick the hair out to the side.

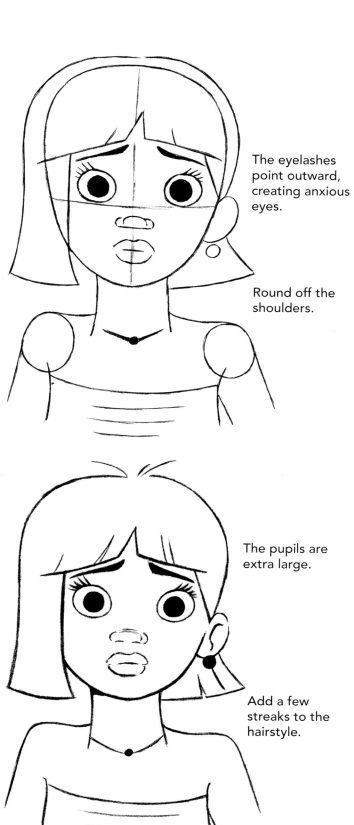

The eyelashes point outward, creating anxious eyes.

Round off the shoulders.

The pupils are extra large.

Add a few streaks to the hairstyle.

Give her a straight-ahead, "deer-in-the-headlights" stare.

Character Type #8
FEARFUL

The fearful character is an important type in animated movies. He creates an arc to the story. In the beginning, he's just a bunch of nerves. But at the end, when he's forced to choose between saving his colleagues or saving himself, he takes a deep breath and runs toward danger. An unexpectedly cool character after all!

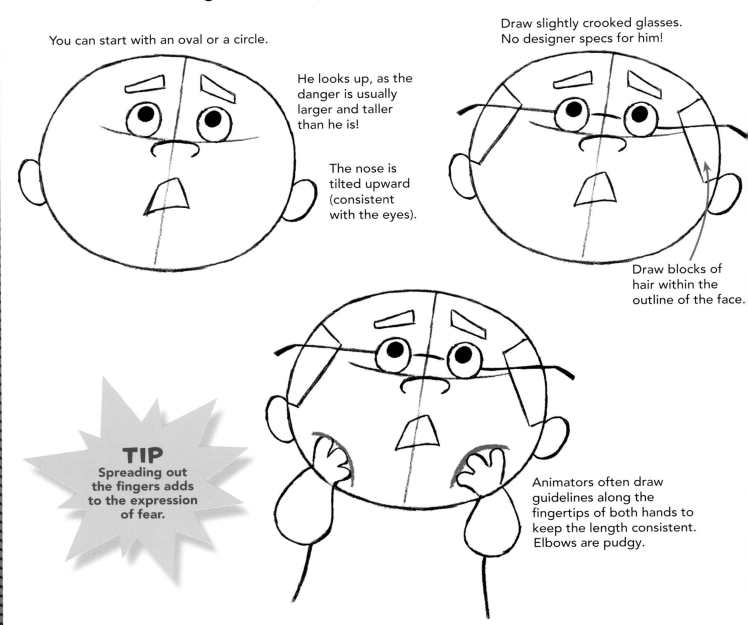

You can start with an oval or a circle.

He looks up, as the danger is usually larger and taller than he is!

The nose is tilted upward (consistent with the eyes).

Draw slightly crooked glasses. No designer specs for him!

Draw blocks of hair within the outline of the face.

TIP
Spreading out the fingers adds to the expression of fear.

Animators often draw guidelines along the fingertips of both hands to keep the length consistent. Elbows are pudgy.

Draw a squiggle of hair on top.

Shave some mass off the sides of the head (red lines) so that it's no longer a circle or an oval.

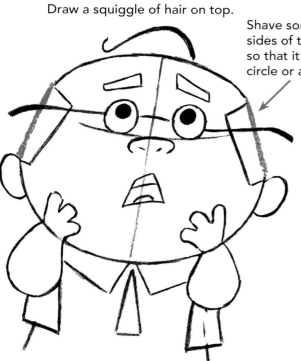

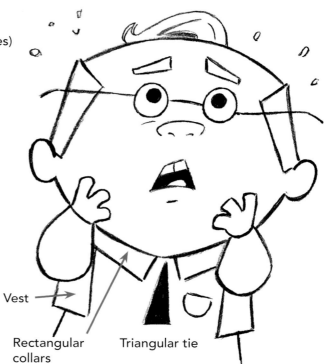

Vest

Rectangular collars

Triangular tie

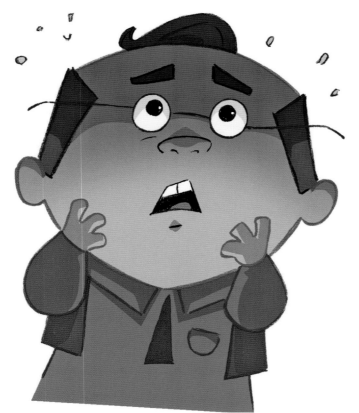

Part of the cute look of this character lies in what's been left out: the neck. The head is fused directly to the body.

Character Type #9
CAN'T RESIST TEMPTATION

It's not like he tries to get into trouble. It's just that so many things capture his interest. There are few characters who get the ball rolling in a story as effectively as this little fella.

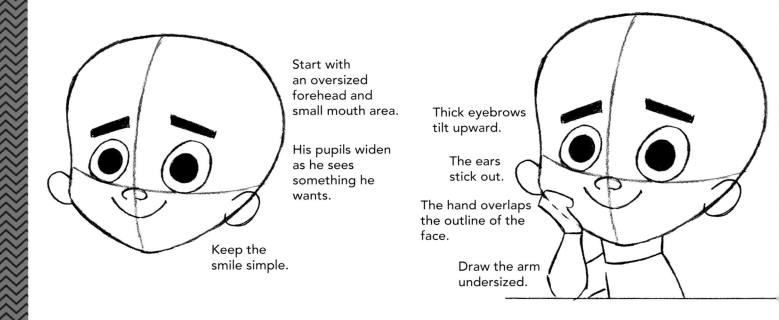

Start with an oversized forehead and small mouth area.

His pupils widen as he sees something he wants.

Keep the smile simple.

Thick eyebrows tilt upward.

The ears stick out.

The hand overlaps the outline of the face.

Draw the arm undersized.

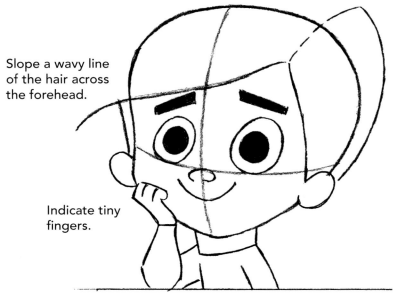

Slope a wavy line of the hair across the forehead.

Indicate tiny fingers.

The outline of the hair extends beyond the outline of the head.

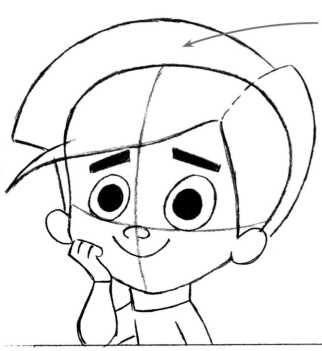

Draw a giant poof of hair on top of the head. Exaggerated hair height is funny on small characters.

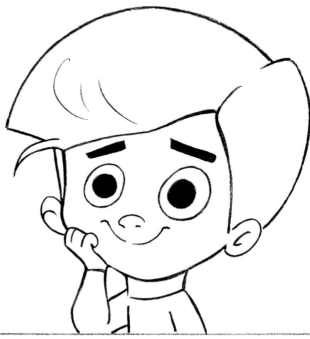

Leave ample white around the pupils.

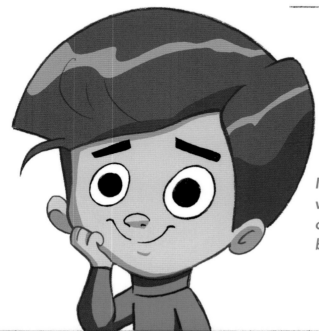

It's always funny when a little character causes big trouble.

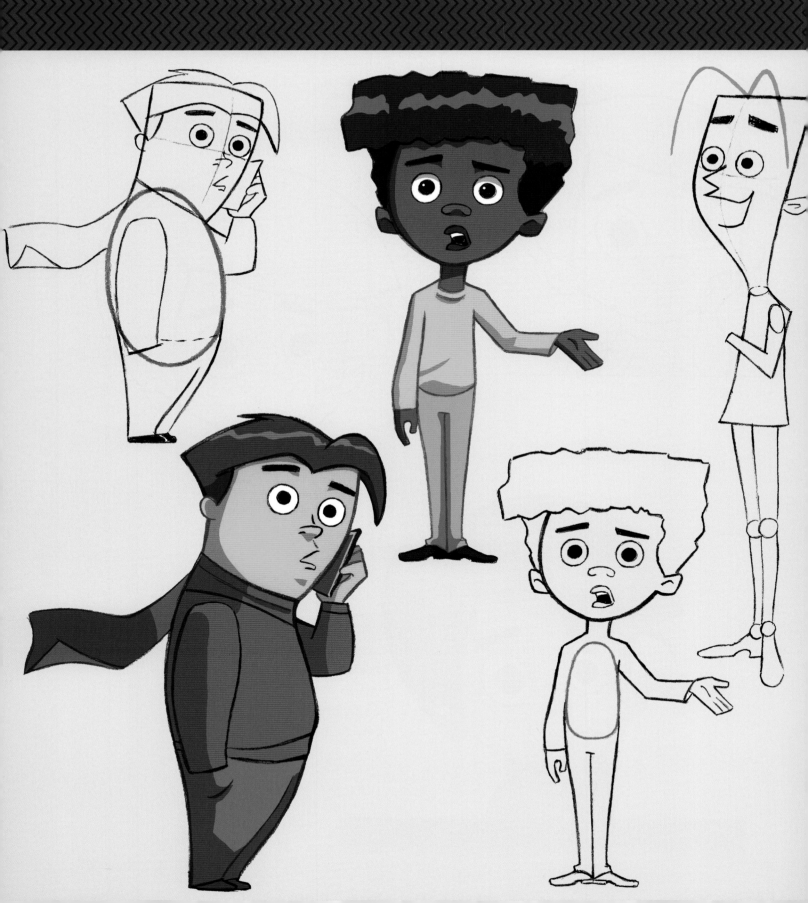

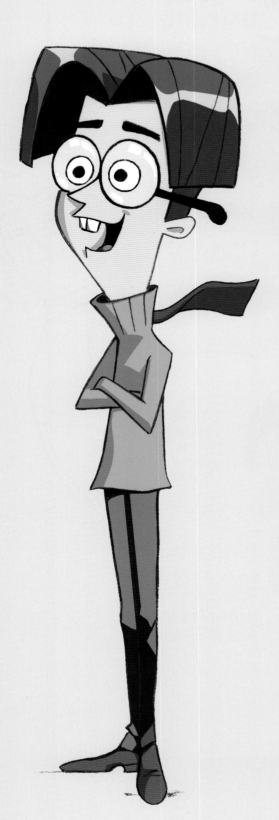

CARTOON BODIES: SIMPLIFY & EXAGGERATE

Cartoon bodies are known for being simplified and exaggerated. You might be tempted to correct for the exaggeration, but your cartoons will be more entertaining if you overdo it than if you underdo it. Here are a few tips to keep in mind as we begin:

- Proportions need to look wrong to be funny.

- Something looks exaggerated only if it's next to something that isn't exaggerated.

- You can exaggerate something by making it smaller or bigger.

Let's see these tips in action!

SUPER-SIMPLIFIED BODIES

Two of the most popular body types in animation are "compact" and "thin." Both types are drawn with ridiculously oversized heads.

COMPACT

This truncated body gives the character an engaging appearance. His head is as long as his torso. Not something you see on most humans.

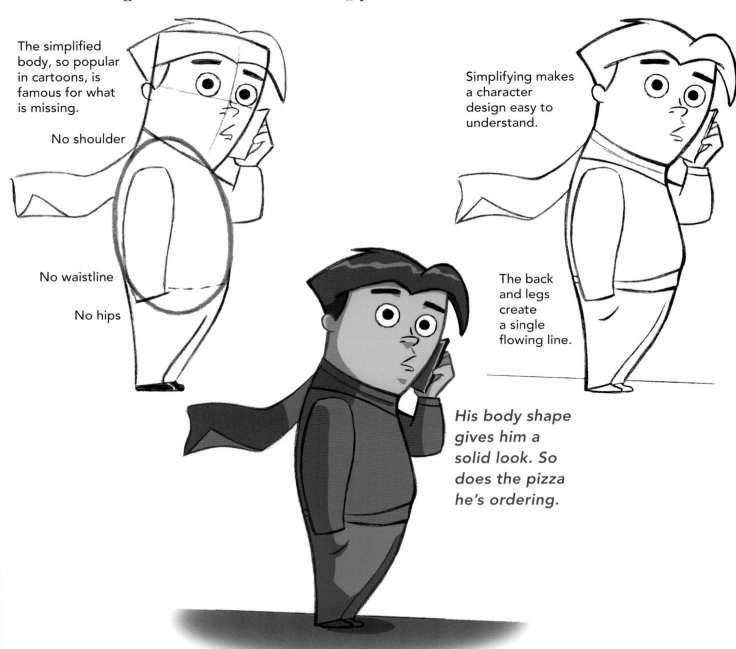

The simplified body, so popular in cartoons, is famous for what is missing.

No shoulder

No waistline

No hips

Simplifying makes a character design easy to understand.

The back and legs create a single flowing line.

His body shape gives him a solid look. So does the pizza he's ordering.

THIN

Simple shapes can also be used as the foundation for thinner bodies.

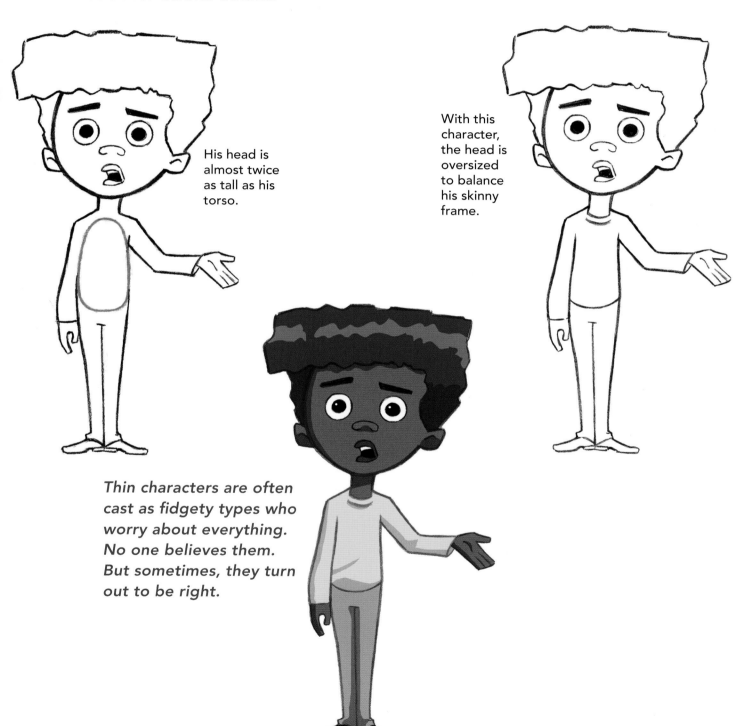

His head is almost twice as tall as his torso.

With this character, the head is oversized to balance his skinny frame.

Thin characters are often cast as fidgety types who worry about everything. No one believes them. But sometimes, they turn out to be right.

SUPER-COMPACT

This body is chunky with a rounded back, a missing waistline, and small arms and legs. He's a lot of fun, and among the easiest characters to draw. His body is so simplified that it appears to restrict his movements, which creates funny poses.

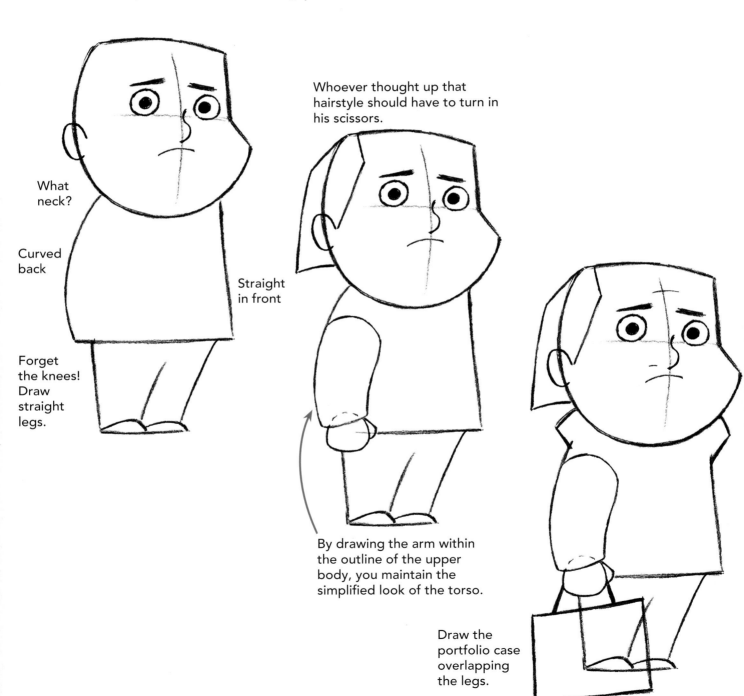

What neck?

Curved back

Forget the knees! Draw straight legs.

Straight in front

Whoever thought up that hairstyle should have to turn in his scissors.

By drawing the arm within the outline of the upper body, you maintain the simplified look of the torso.

Draw the portfolio case overlapping the legs.

TIP FOR EXAGGERATING PROPORTIONS

When you reduce the width of a character, you normalize him. But that may not be what you want for this character. Take a look.

An exaggerated head with a normal body looks wrong.

An exaggerated head with an exaggerated body is wrong, but looks right!

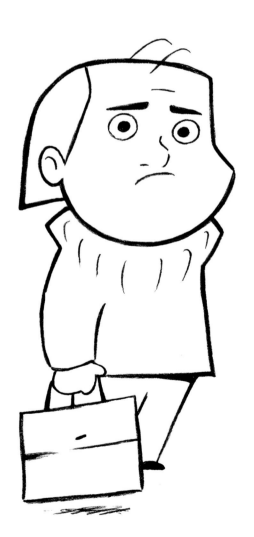

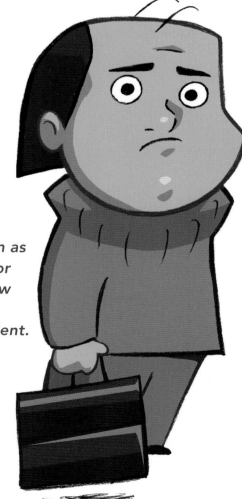

I envision him as an art director about to show his work to a nightmare client. "Do it over!"

CHARMING PROPORTIONS

With all cartoon bodies, the shape is influenced by the character type. The proportions for this cute character are simple: an oversized, rounded head with a tiny body—and even tinier arms and legs.

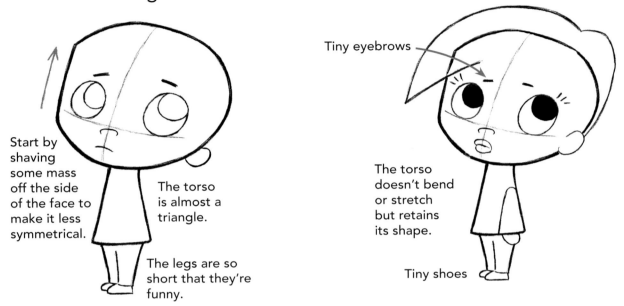

Start by shaving some mass off the side of the face to make it less symmetrical.

The torso is almost a triangle.

The legs are so short that they're funny.

Tiny eyebrows

The torso doesn't bend or stretch but retains its shape.

Tiny shoes

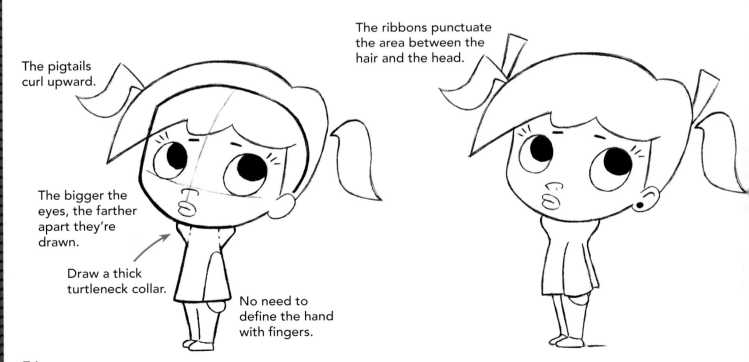

The pigtails curl upward.

The bigger the eyes, the farther apart they're drawn.

Draw a thick turtleneck collar.

No need to define the hand with fingers.

The ribbons punctuate the area between the hair and the head.

BIG HEAD, LITTLE BODY

Little kid characters are often drawn with the head plopped on top of the body, right on the shoulders.

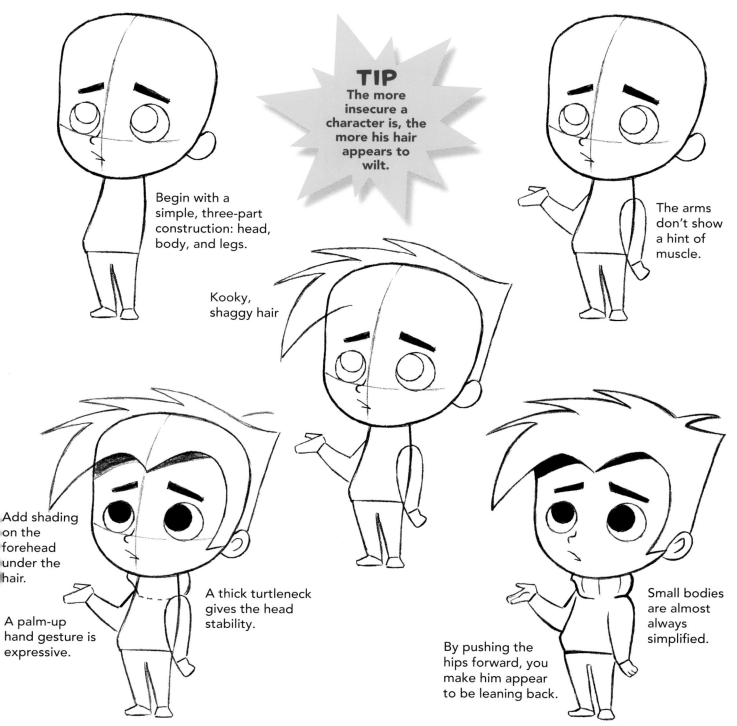

Begin with a simple, three-part construction: head, body, and legs.

TIP
The more insecure a character is, the more his hair appears to wilt.

The arms don't show a hint of muscle.

Kooky, shaggy hair

Add shading on the forehead under the hair.

A palm-up hand gesture is expressive.

A thick turtleneck gives the head stability.

By pushing the hips forward, you make him appear to be leaning back.

Small bodies are almost always simplified.

SKINNY GUY

This body type has achieved a favored status among fans of animated cartoons. His upper body is a noodle. His legs are two noodles. These highly stylized character types are appealing and easy to draw.

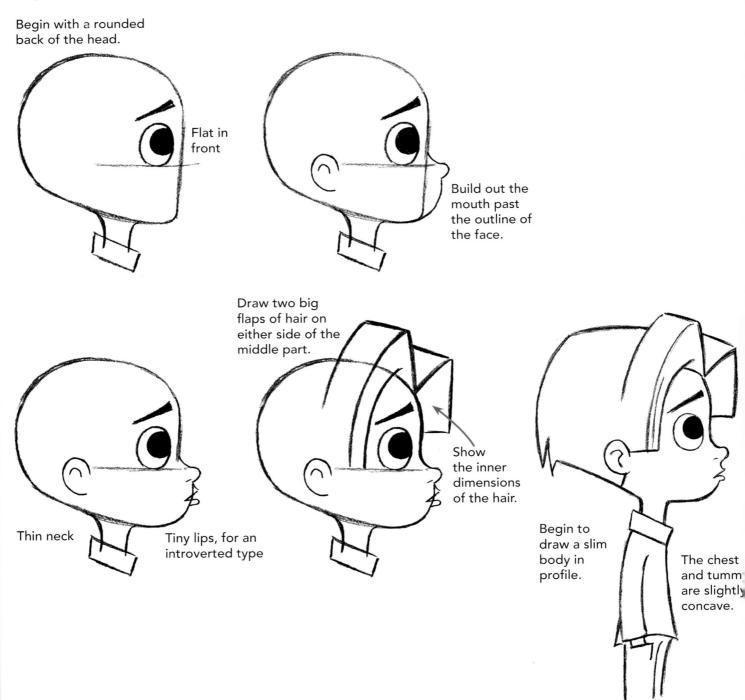

Begin with a rounded back of the head.

Flat in front

Build out the mouth past the outline of the face.

Draw two big flaps of hair on either side of the middle part.

Show the inner dimensions of the hair.

Thin neck

Tiny lips, for an introverted type

Begin to draw a slim body in profile.

The chest and tumm are slightly concave.

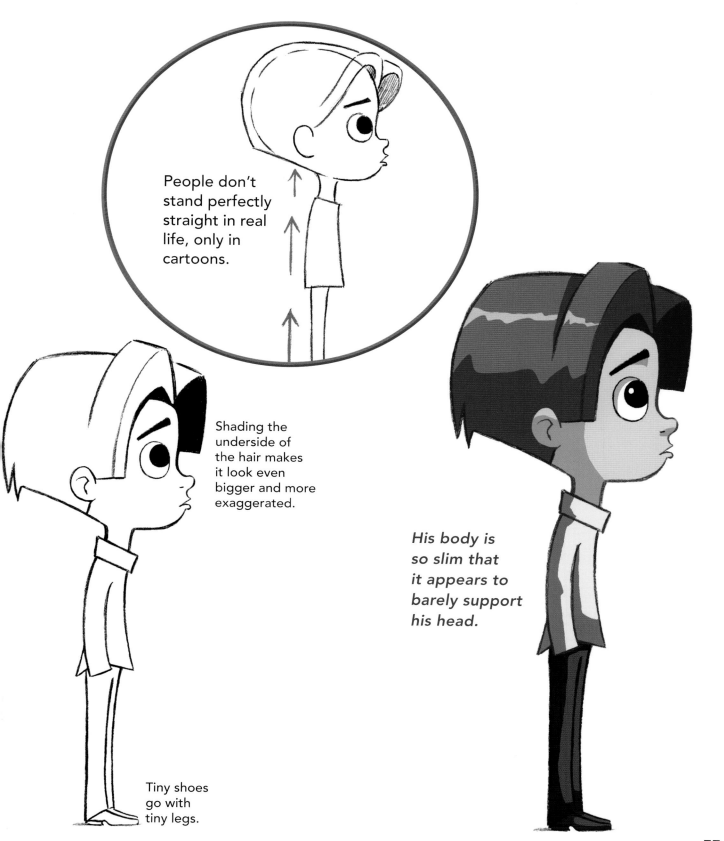

People don't stand perfectly straight in real life, only in cartoons.

Shading the underside of the hair makes it look even bigger and more exaggerated.

His body is so slim that it appears to barely support his head.

Tiny shoes go with tiny legs.

77

NARROW AND TALL

Some characters are not only narrow but also tall, exaggerating them even further. This technique is often successfully applied to personality types such as villains, eccentrics, and more.

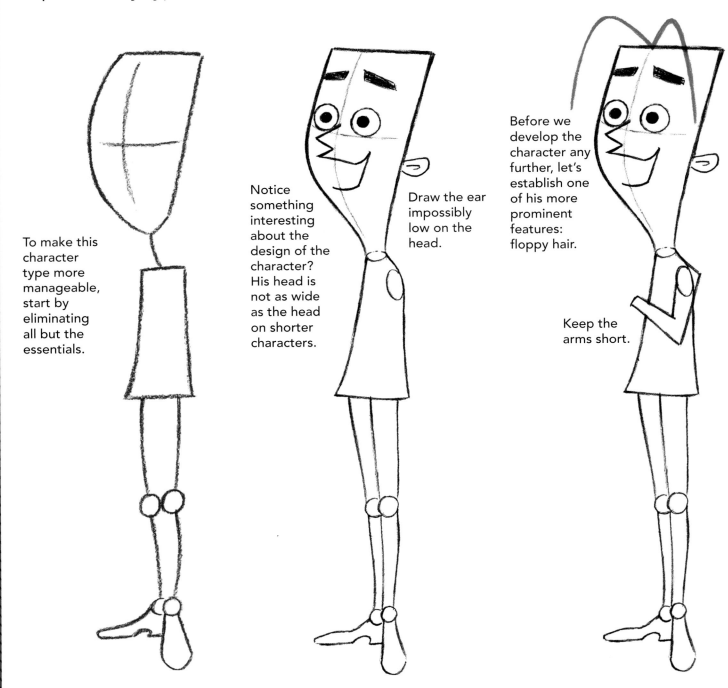

To make this character type more manageable, start by eliminating all but the essentials.

Notice something interesting about the design of the character? His head is not as wide as the head on shorter characters.

Draw the ear impossibly low on the head.

Before we develop the character any further, let's establish one of his more prominent features: floppy hair.

Keep the arms short.

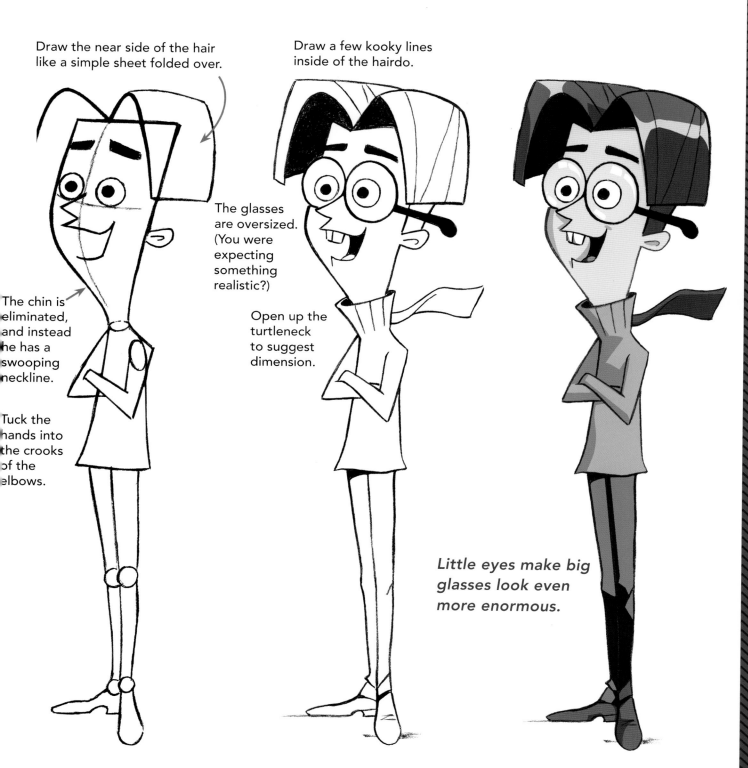

Draw the near side of the hair like a simple sheet folded over.

Draw a few kooky lines inside of the hairdo.

The glasses are oversized. (You were expecting something realistic?)

The chin is eliminated, and instead he has a swooping neckline.

Tuck the hands into the crooks of the elbows.

Open up the turtleneck to suggest dimension.

Little eyes make big glasses look even more enormous.

ODDBALL CHARACTERS

These are among my favorite character types. Normally, if you're drawing a character and it's beginning to look awkward, you go back and correct it. But with the oddball type, if the drawing is starting to look curious, keep going!

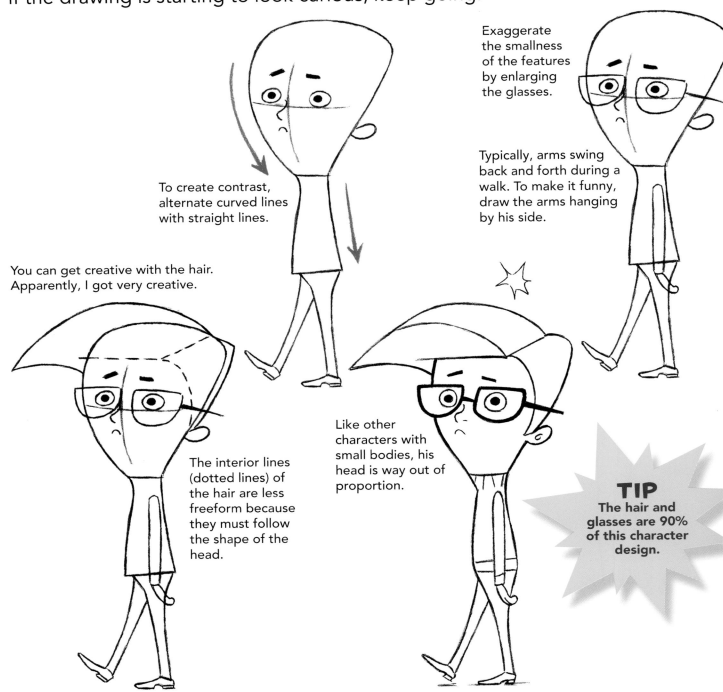

To create contrast, alternate curved lines with straight lines.

Exaggerate the smallness of the features by enlarging the glasses.

Typically, arms swing back and forth during a walk. To make it funny, draw the arms hanging by his side.

You can get creative with the hair. Apparently, I got very creative.

The interior lines (dotted lines) of the hair are less freeform because they must follow the shape of the head.

Like other characters with small bodies, his head is way out of proportion.

TIP
The hair and glasses are 90% of this character design.

THE "AVERAGE" KID BODY

The characters in the previous chapter were stylishly simple, which is funny, but not ideal for drawing expressive poses. With only a few modifications, we can create bodies with proportions that are entertaining but also easy to pose, like this one.

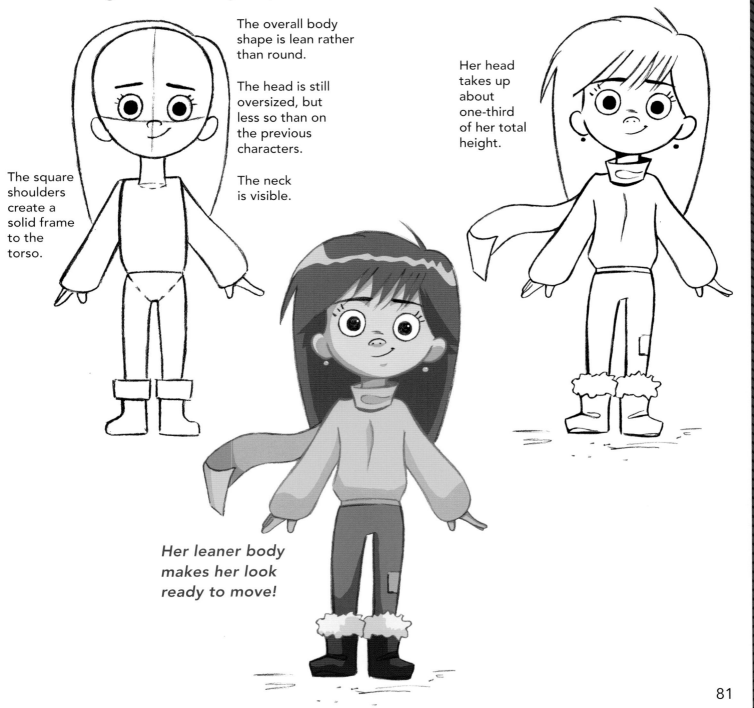

The overall body shape is lean rather than round.

The head is still oversized, but less so than on the previous characters.

The neck is visible.

The square shoulders create a solid frame to the torso.

Her head takes up about one-third of her total height.

Her leaner body makes her look ready to move!

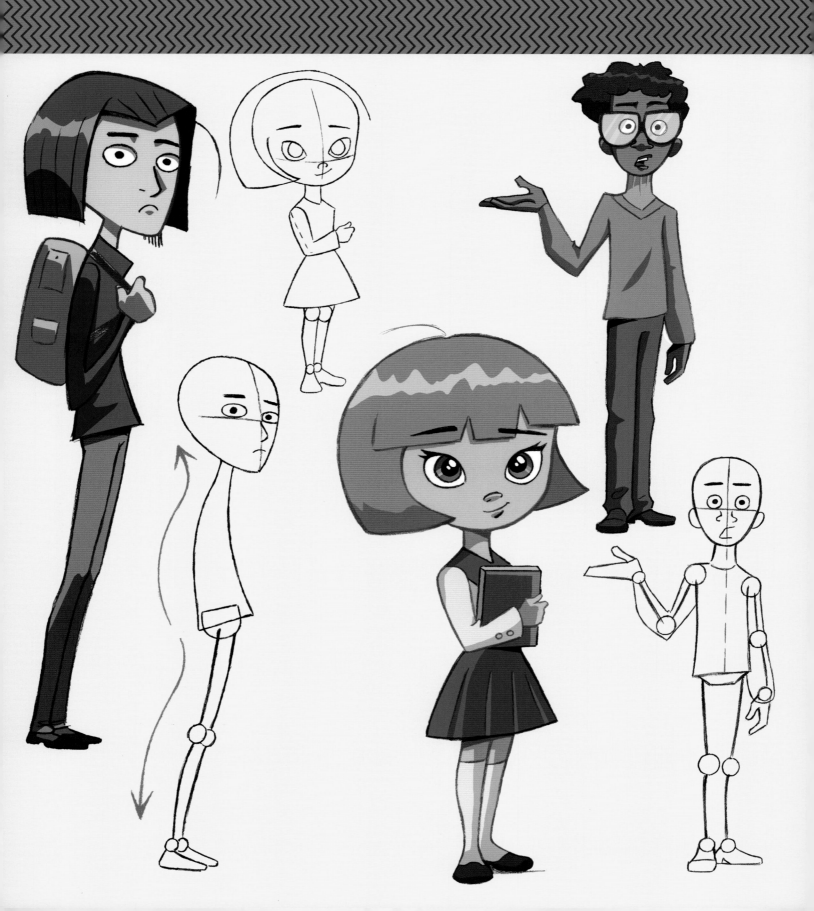

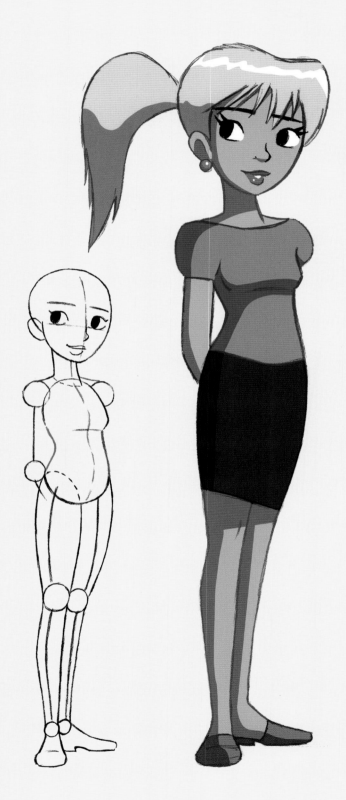

MODIFYING CARTOON BODIES

Characters with heavily exaggerated bodies are fun to draw and popular as well. But they're also limited in how we can pose them. Poses require flexibility, which simplified characters usually don't have, so we'll need to normalize the figure. Without the modifications I'll introduce in this chapter, our characters would not have enough flexibility to strike interesting poses, which is what we're building up to.

BASIC BODY CONSTRUCTION

Slightly more realistic proportions give us the clues to draw cartoons based on a logical construction rather than relying solely on exaggeration.

FEMALE PROPORTIONS

MALE PROPORTIONS

CLASSIC PROPORTIONS

The average cartoon body has a small torso and long legs. This is reversed on character types such as villains, who often have large upper bodies (for power) and short legs.

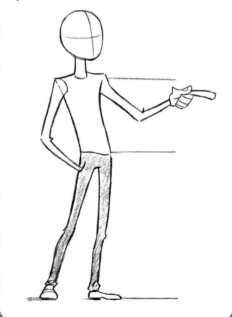

The collarbone runs across both shoulders.

The female's waistline is higher than the male's.

The elbows are drawn at the level of the midsection.

The hips are wide.

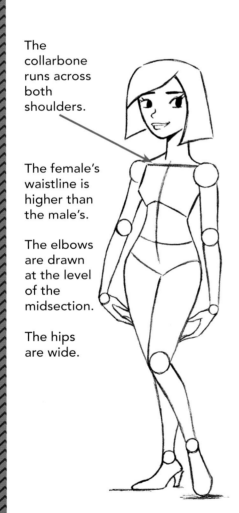

His chest and collarbone are wide.

The waistline is low, and the hips are narrow.

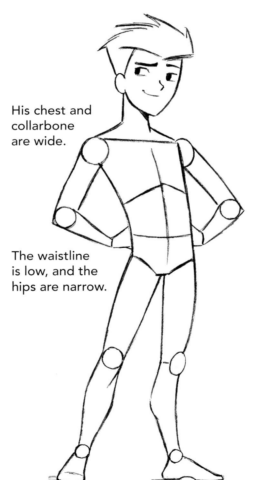

SIMPLIFIED VS. FLEXIBLE BODIES

Poses are effective for simplified characters—if the poses are humorous and stiff. However, if you'd like to show more natural gestures or emotions with some subtlety, you'll need a body type that can move.

STIFF BODY TYPE

The thing that makes the body stiff is the lack of a movable midsection, as shown in the blue area. There is none. Therefore, the sections of the body don't move or twist independently.

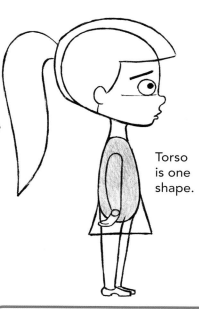

Torso is one shape.

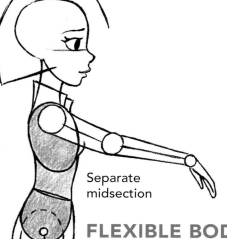

Separate midsection

FLEXIBLE BODY TYPE

Once we create a midsection, the body can twist, stretch, turn, and bend. Now there are many more possibilities for poses and gestures.

TWIST AND TURN

This type of movement is hard to achieve with the simplified body type, which we covered in the previous chapter. However, if we simply add a waistline, the body is able to twist and bend.

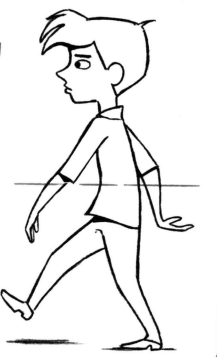

85

ADDING A WAISTLINE

This character has something that compact, highly exaggerated characters do not: a waistline! The indented waistline adds variety to the outline of the figure.

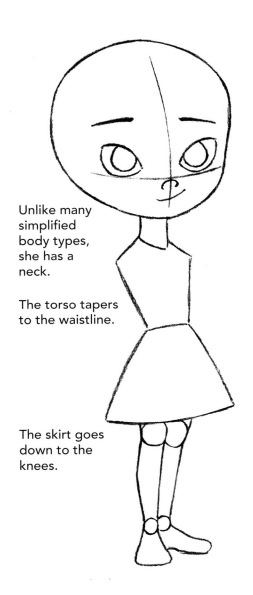

Unlike many simplified body types, she has a neck.

The torso tapers to the waistline.

The skirt goes down to the knees.

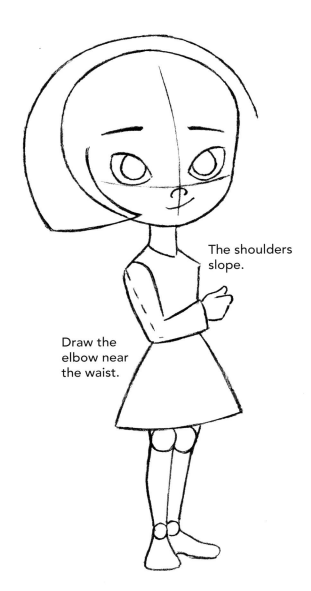

The shoulders slope.

Draw the elbow near the waist.

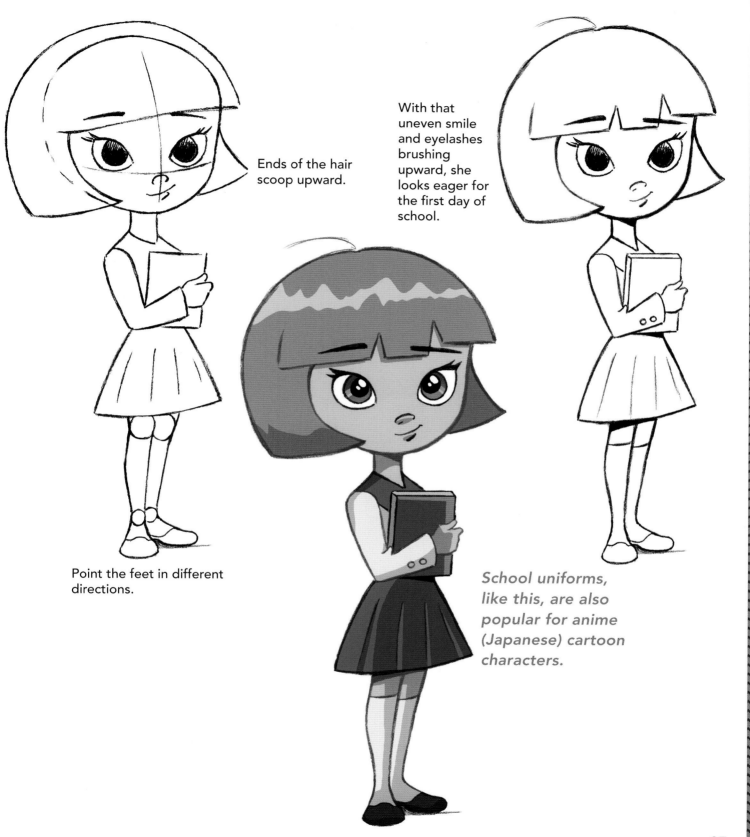

Ends of the hair scoop upward.

Point the feet in different directions.

With that uneven smile and eyelashes brushing upward, she looks eager for the first day of school.

School uniforms, like this, are also popular for anime (Japanese) cartoon characters.

87

EXAGGERATING THE NORMAL BODY

To create a cartoon version of a real body, compress it and elongate the legs. Audiences relate to these types of characters. Even though it's a cartoon, there's something real-looking about it.

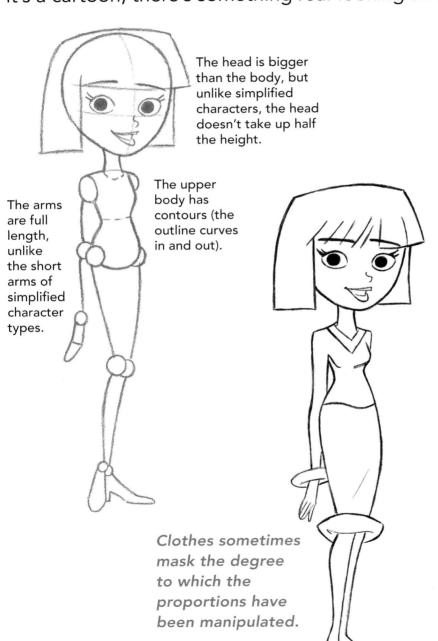

The head is bigger than the body, but unlike simplified characters, the head doesn't take up half the height.

The arms are full length, unlike the short arms of simplified character types.

The upper body has contours (the outline curves in and out).

Clothes sometimes mask the degree to which the proportions have been manipulated.

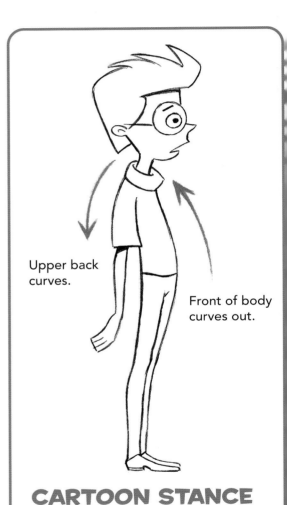

Upper back curves.

Front of body curves out.

CARTOON STANCE

How a character stands is part of his or her individual look. We exaggerate these dynamics in order to make the stance entertaining.

VISUAL RHYTHM

Certain visual rhythms exist along the body. Whether they're in the proportions or the contours, they can be brought out and enhanced. This has a positive effect on the viewer. For example, each of the limbs on this character is drawn with one side curved and the opposing side straight. It's an exaggeration, of course, but it's there.

GOOD!

The top side of the arm is drawn with a straight line, while the underside is curvy. The contrast is appealing.

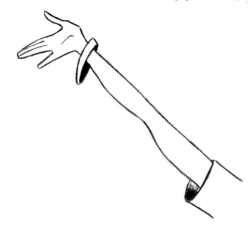

NOT QUITE AS GOOD . . .

When both sides of the arm are drawn with curvy lines, the result looks a little wobbly.

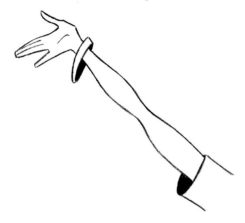

The muscular side of the forearm is curvy (red).

The bone side is straight (blue).

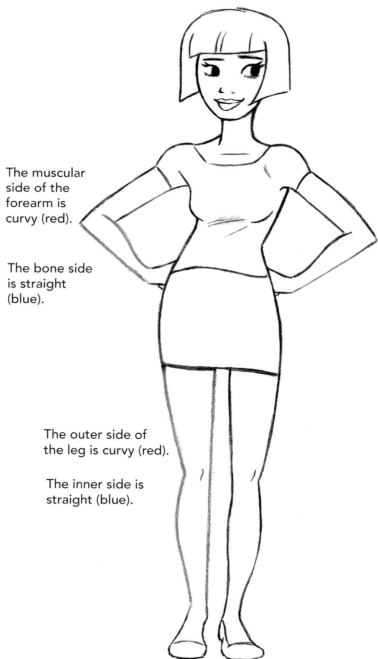

The outer side of the leg is curvy (red).

The inner side is straight (blue).

THE THREE FOUNDATION POSES

Most cartoon poses fit into one of three categories: front view, side view, and three-quarter view. Back views are usually avoided because they don't give the audience a good look at the character.

FRONT VIEW

The front view is the most straightforward pose as it is mostly symmetrical. But it creates impact, especially when the character looks directly at you.

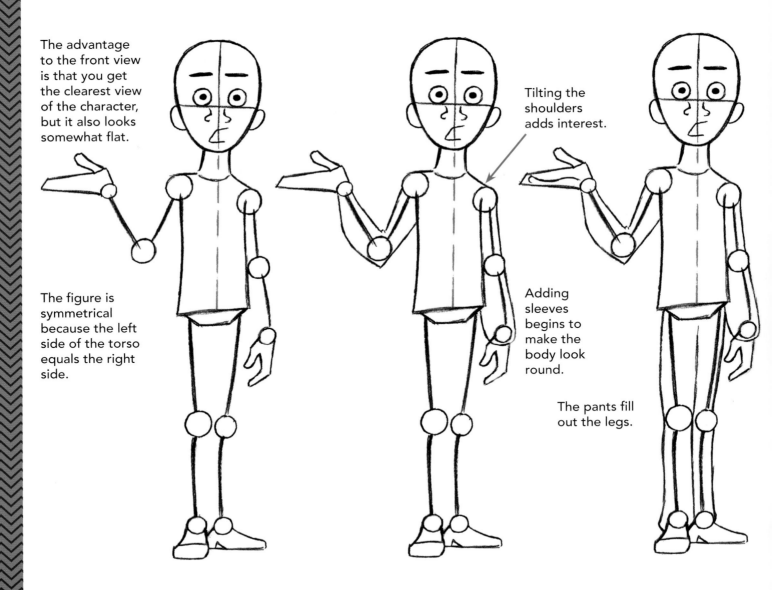

The advantage to the front view is that you get the clearest view of the character, but it also looks somewhat flat.

The figure is symmetrical because the left side of the torso equals the right side.

Tilting the shoulders adds interest.

Adding sleeves begins to make the body look round.

The pants fill out the legs.

Raising one hand and twisting his mouth to the side makes the otherwise symmetrical pose more dynamic.

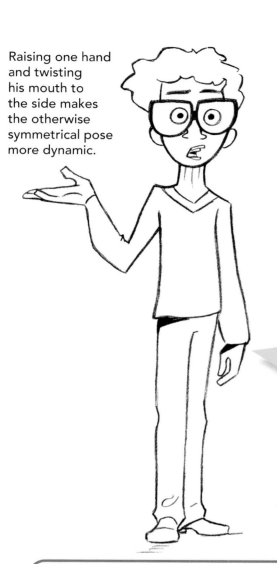

Although he appears to be explaining something, it's not clear that he knows what he's talking about.

TIP
Some expressions are funnier at certain angles. For example, a character who looks at the viewer is funnier in a front view.

MAINTAINING YOUR CHARACTER IN DIFFERENT POSES

How do you keep one character looking the same in different directions, and in different poses? Here's the key: Make sure the one on the left has the same general proportions as the one on the right. For example, are the eyes as high on both characters? Are the hips as wide as the shoulders on both versions? Rough sketching can be very helpful here, because you'll most likely have to make many small adjustments as you go.

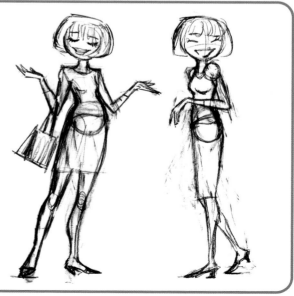

91

SIDE VIEW

The side view is like a silhouette of the body.
Keep it clear and simple.

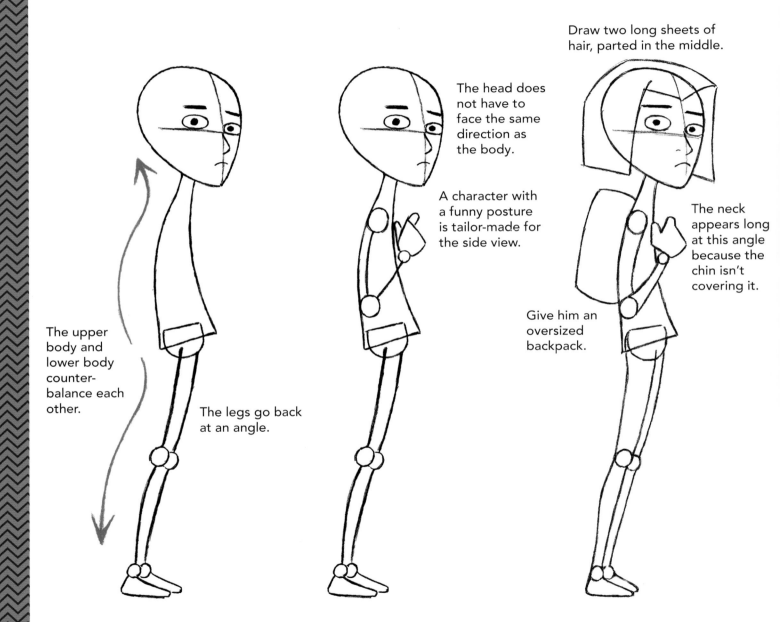

The upper body and lower body counter-balance each other.

The legs go back at an angle.

The head does not have to face the same direction as the body.

A character with a funny posture is tailor-made for the side view.

Draw two long sheets of hair, parted in the middle.

The neck appears long at this angle because the chin isn't covering it.

Give him an oversized backpack.

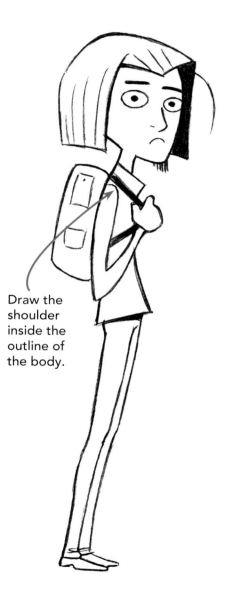

Draw the shoulder inside the outline of the body.

GRADES

THREE-QUARTER VIEW

In this three-quarter angle pose, the character is turned slightly to the right, which causes the left side to look somewhat larger. This creates a dynamic standing pose.

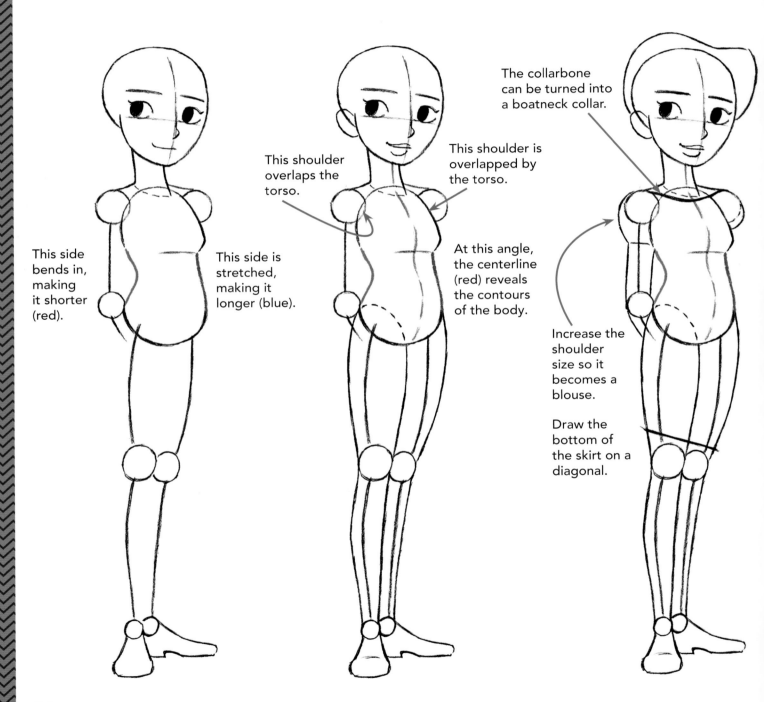

This side bends in, making it shorter (red).

This side is stretched, making it longer (blue).

This shoulder overlaps the torso.

This shoulder is overlapped by the torso.

At this angle, the centerline (red) reveals the contours of the body.

The collarbone can be turned into a boatneck collar.

Increase the shoulder size so it becomes a blouse.

Draw the bottom of the skirt on a diagonal.

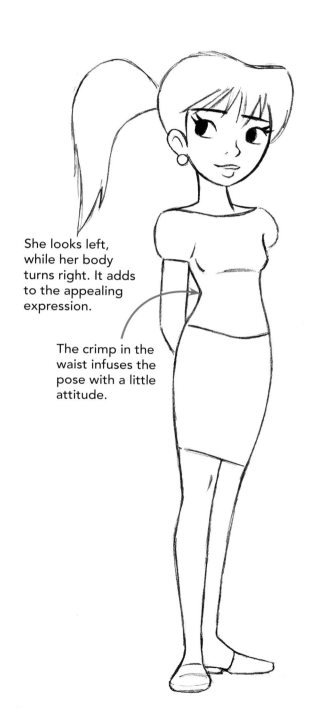

She looks left, while her body turns right. It adds to the appealing expression.

The crimp in the waist infuses the pose with a little attitude.

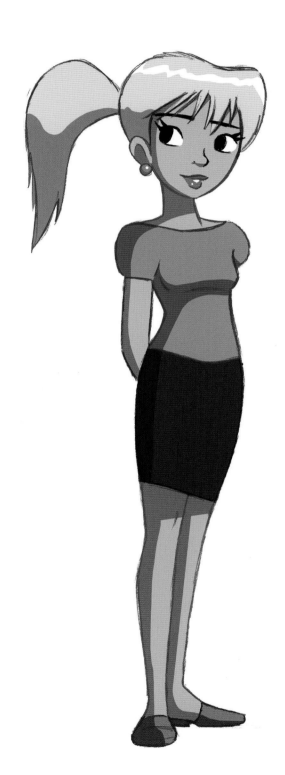

95

GOOD POSTURE IN THE SIDE ANGLE

It's easy to see the mechanics of the standing figure in a side view. Very little of the spine is straight. It mostly curves.

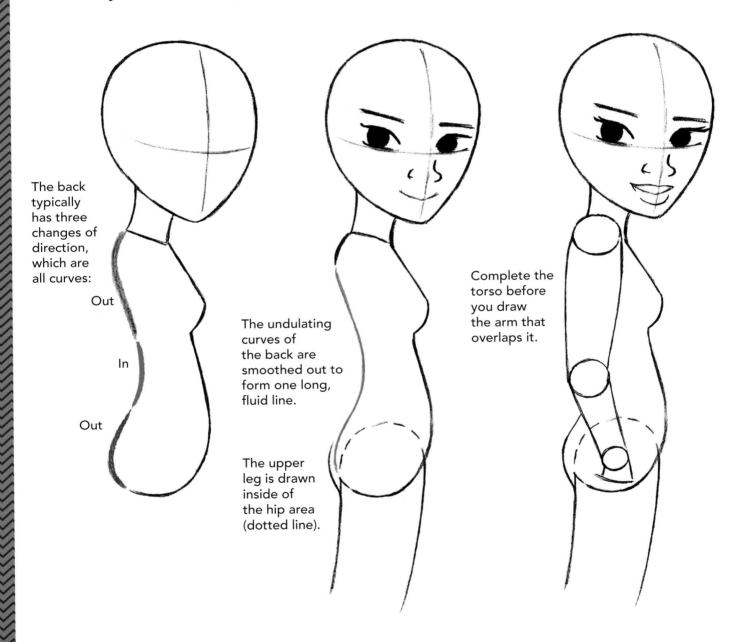

The back typically has three changes of direction, which are all curves:

Out

In

Out

The undulating curves of the back are smoothed out to form one long, fluid line.

The upper leg is drawn inside of the hip area (dotted line).

Complete the torso before you draw the arm that overlaps it.

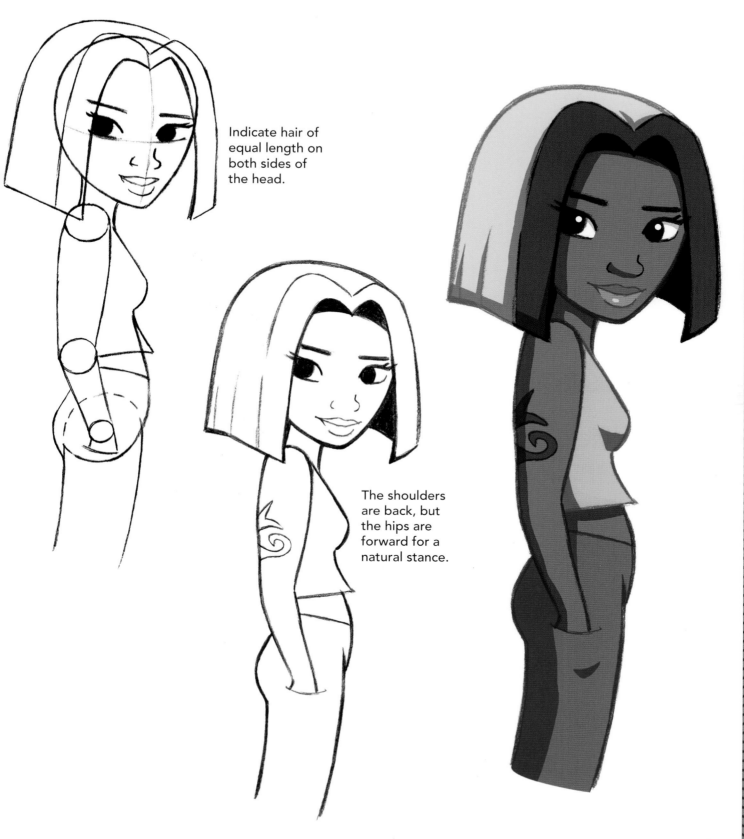

Indicate hair of equal length on both sides of the head.

The shoulders are back, but the hips are forward for a natural stance.

97

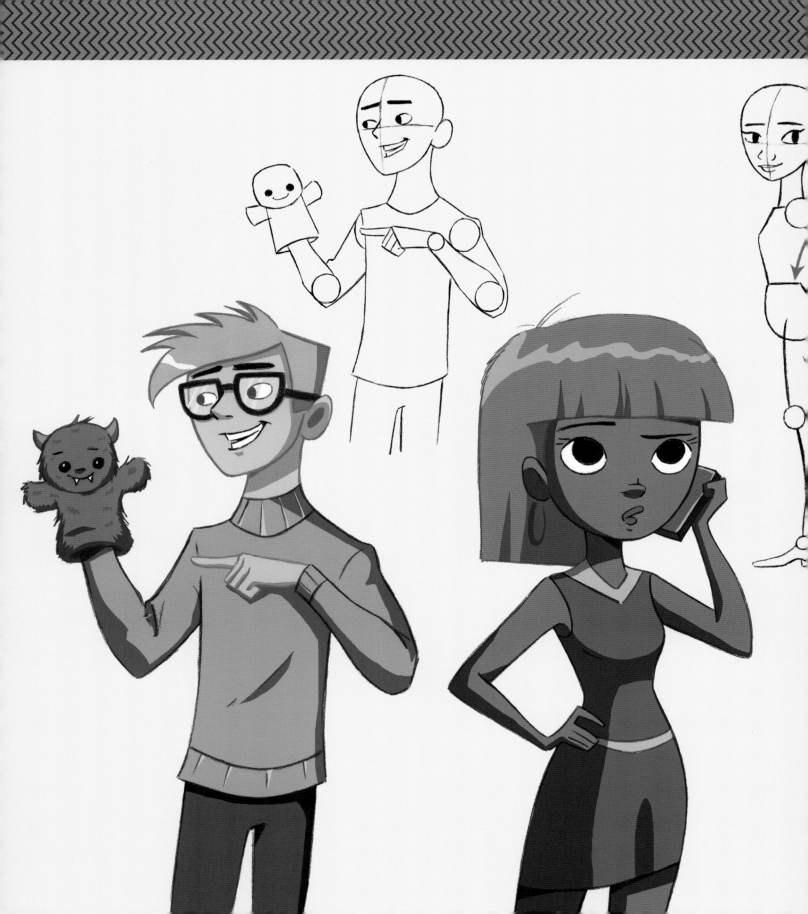

MUST-KNOW POSES FOR EVERY CARTOONIST

Now that you're well on your way to learning to draw a variety of cartoon characters and even invent your own, it's time to bring your characters to life by drawing them in different poses. In this chapter, we'll explore a range of appealing poses, actions, and gestures, from talking on the phone, to classic standing poses, to several different styles of walking. Let's give them a try.

ON THE PHONE

Every cartoonist needs to know how to draw this pose, which we see in real people every day. We already know where the hand with the phone goes. But what about the free hand? Let's use it to add some attitude to the pose.

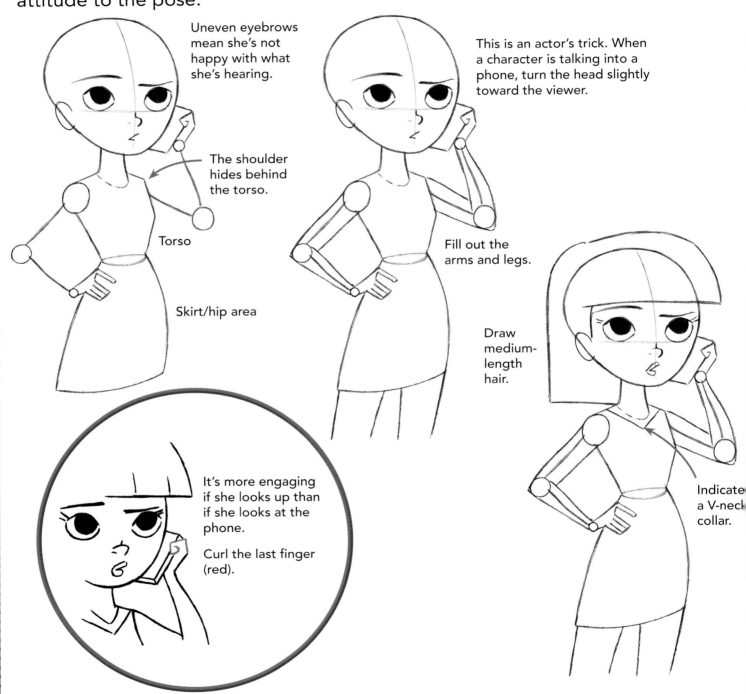

Uneven eyebrows mean she's not happy with what she's hearing.

The shoulder hides behind the torso.

Torso

Skirt/hip area

This is an actor's trick. When a character is talking into a phone, turn the head slightly toward the viewer.

Fill out the arms and legs.

Draw medium-length hair.

Indicate a V-neck collar.

It's more engaging if she looks up than if she looks at the phone.

Curl the last finger (red).

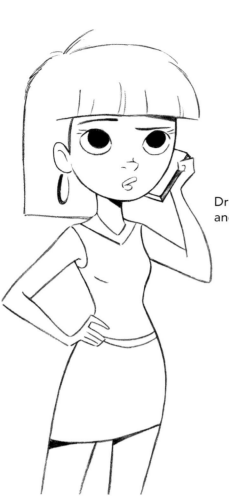

Draw a collar and belt line.

Even bubbly characters get annoyed.

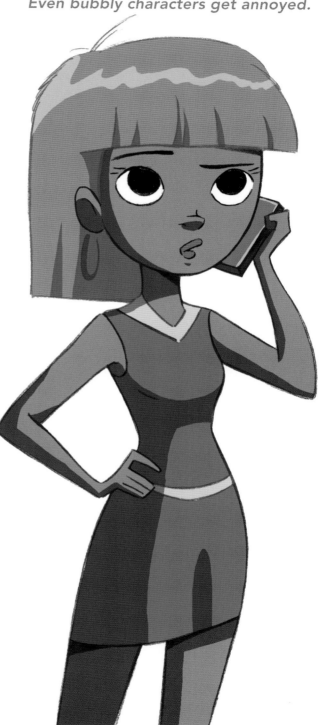

The hips are the fulcrum of the pose. The torso and legs attach to the hips.

DUMB DAD JOKES

You can be the coolest guy in the world, but the moment you become a dad, this happens: You look forward to getting slippers for your birthday. You need glasses to read the ingredients label on food packaging. And your kids groan when you try to tell a joke.

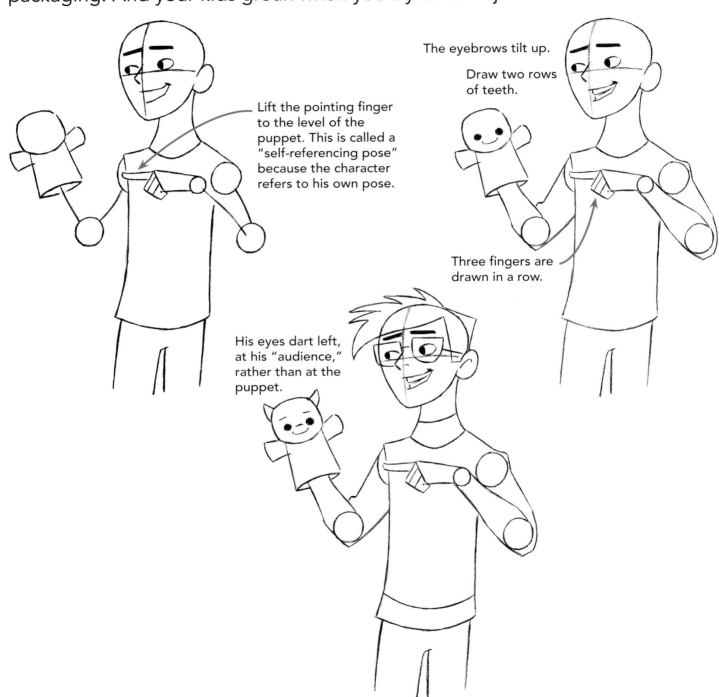

Lift the pointing finger to the level of the puppet. This is called a "self-referencing pose" because the character refers to his own pose.

The eyebrows tilt up.

Draw two rows of teeth.

Three fingers are drawn in a row.

His eyes dart left, at his "audience," rather than at the puppet.

Ruffled hair reflects an active pose.

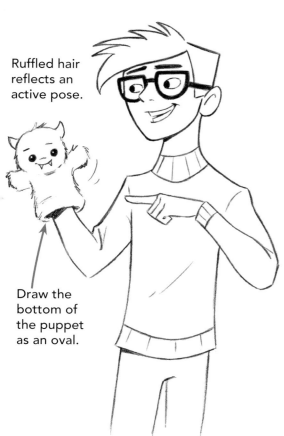

Draw the bottom of the puppet as an oval.

"So the monster said to the other monster..."

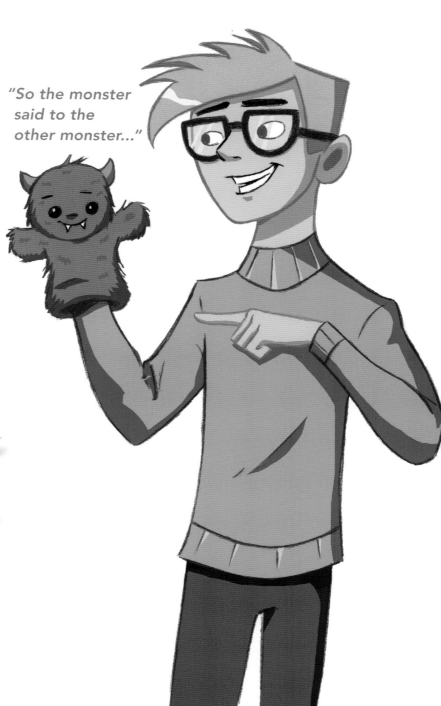

TIP
This pose is cut off around the knees. If we showed his entire figure, we couldn't get in this close, and the pose would lose some impact.

103

THE DOWNSIDE TO HAVING A PET

The front view is great for a frozen look. He looks embarrassed. Was it mean of me to draw him that way?

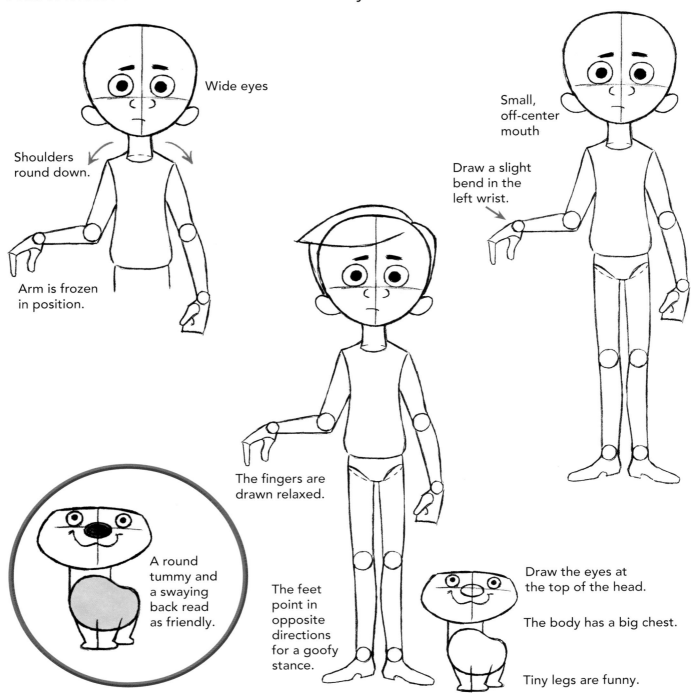

Wide eyes

Shoulders round down.

Arm is frozen in position.

Small, off-center mouth

Draw a slight bend in the left wrist.

The fingers are drawn relaxed.

A round tummy and a swaying back read as friendly.

The feet point in opposite directions for a goofy stance.

Draw the eyes at the top of the head.

The body has a big chest.

Tiny legs are funny.

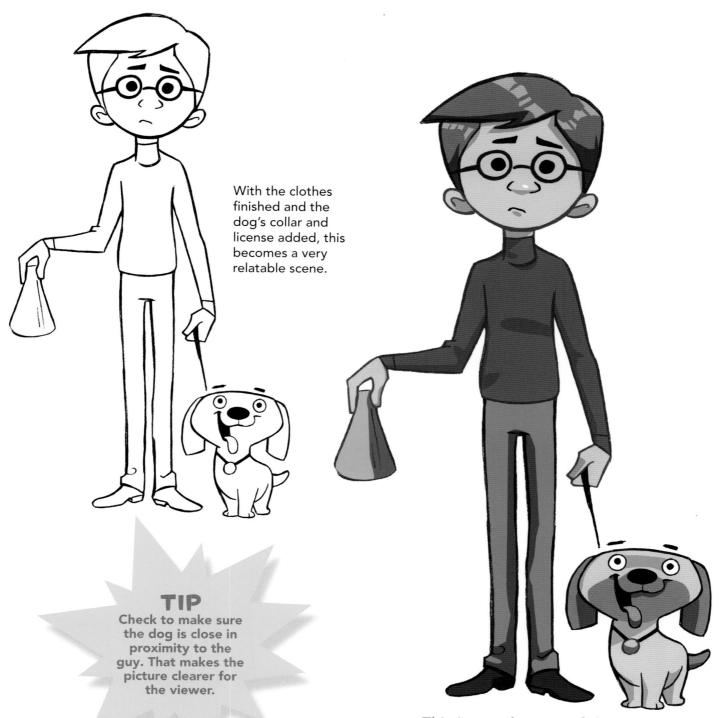

With the clothes finished and the dog's collar and license added, this becomes a very relatable scene.

TIP
Check to make sure the dog is close in proximity to the guy. That makes the picture clearer for the viewer.

This is not the sort of doggie bag one wants to bring home.

HANDS ON HIPS

This is one of the most useful poses. It can be drawn with the hands or fists on the hips, and it can communicate the following attitudes:

- Ego
- Impatience
- Stubbornness
- Skepticism
- Puzzlement

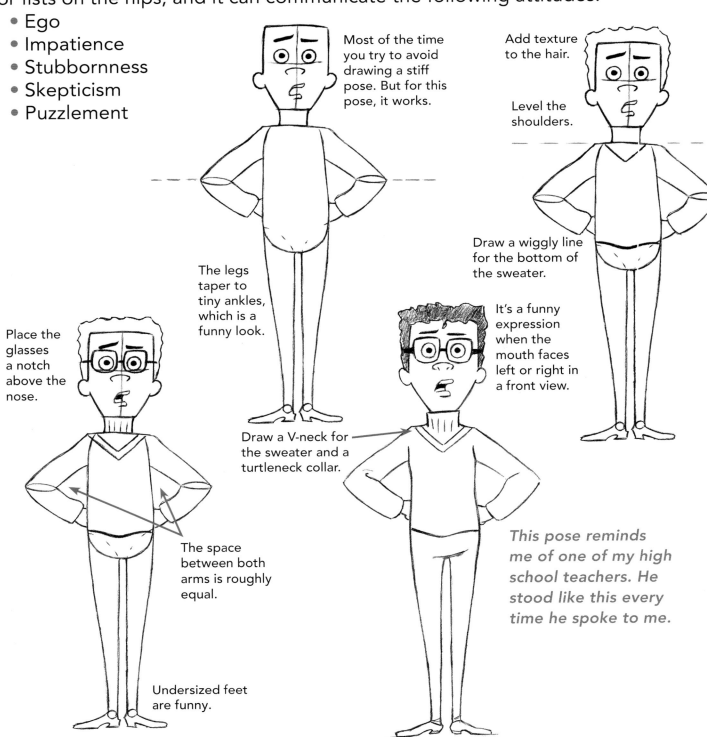

Most of the time you try to avoid drawing a stiff pose. But for this pose, it works.

Add texture to the hair.

Level the shoulders.

Draw a wiggly line for the bottom of the sweater.

The legs taper to tiny ankles, which is a funny look.

Place the glasses a notch above the nose.

It's a funny expression when the mouth faces left or right in a front view.

Draw a V-neck for the sweater and a turtleneck collar.

The space between both arms is roughly equal.

Undersized feet are funny.

This pose reminds me of one of my high school teachers. He stood like this every time he spoke to me.

CROSSED LEGS

This is an excellent choice when you want to put some variety into a standing pose. It's simple to draw. I'll give you a few tips to get you started.

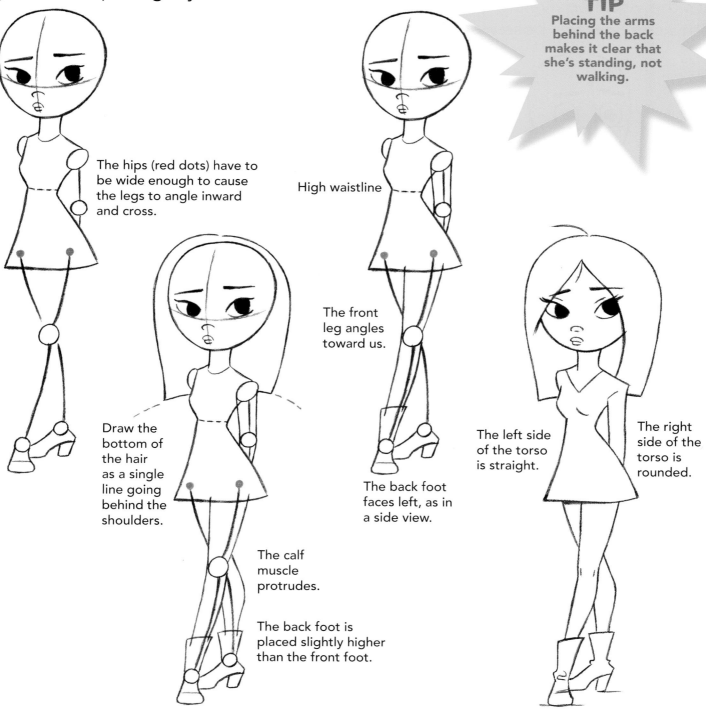

TIP
Placing the arms behind the back makes it clear that she's standing, not walking.

The hips (red dots) have to be wide enough to cause the legs to angle inward and cross.

High waistline

The front leg angles toward us.

Draw the bottom of the hair as a single line going behind the shoulders.

The calf muscle protrudes.

The back foot is placed slightly higher than the front foot.

The back foot faces left, as in a side view.

The left side of the torso is straight.

The right side of the torso is rounded.

THE FAMOUS SHOULDER SHRUG

This is a gesture that works in many situations. It's the visual equivalent of saying, "I don't know." Let's see how this pose works.

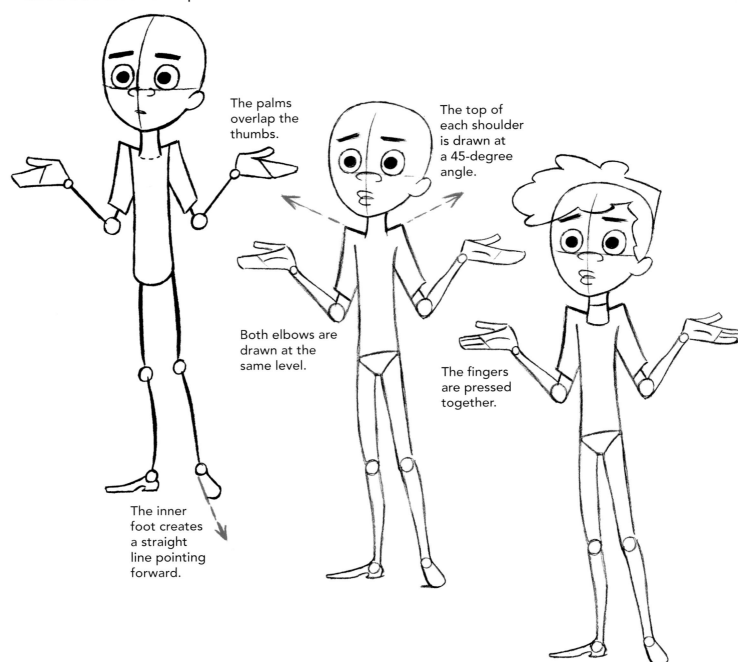

The palms overlap the thumbs.

The top of each shoulder is drawn at a 45-degree angle.

Both elbows are drawn at the same level.

The fingers are pressed together.

The inner foot creates a straight line pointing forward.

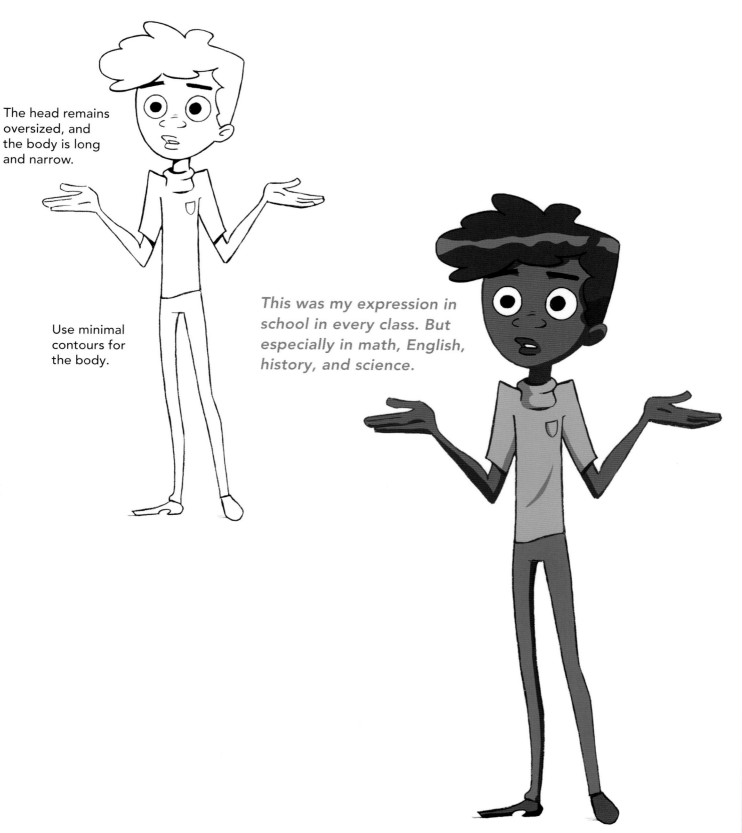

The head remains oversized, and the body is long and narrow.

Use minimal contours for the body.

This was my expression in school in every class. But especially in math, English, history, and science.

THE ACCIDENTAL POSE

Sometimes a character appears to have been interrupted mid-motion. This is called an accidental pose. Let's see how we can get that look of spontaneity.

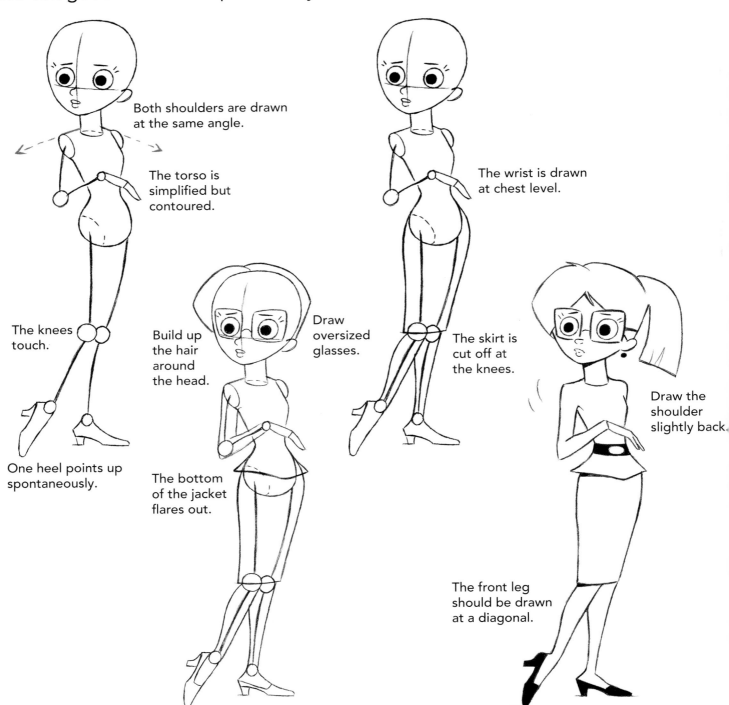

Both shoulders are drawn at the same angle.

The torso is simplified but contoured.

The knees touch.

One heel points up spontaneously.

Build up the hair around the head.

Draw oversized glasses.

The bottom of the jacket flares out.

The wrist is drawn at chest level.

The skirt is cut off at the knees.

Draw the shoulder slightly back.

The front leg should be drawn at a diagonal.

WALKING POSES

A walking pose usually has an attitude. For example, a walk could be hurried or it could be casual. The facial expression isn't as important as the posture. We'll look at a few popular examples, with some tips on how to draw them. These can be applied to different character types.

WORRIED WALK

Many types of walks are drawn with the head held high. Not so with the worried walk. It's all about leaning forward. This pose immediately communicates an inward-focused mind-set.

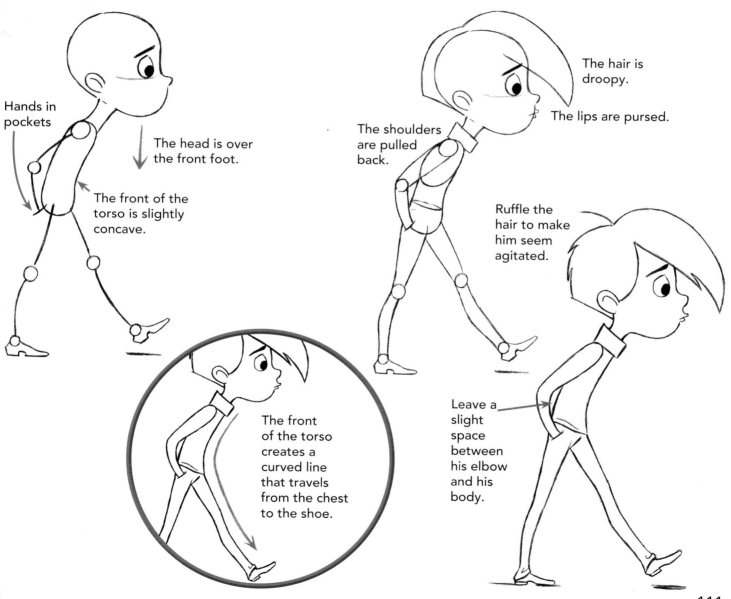

Hands in pockets

The head is over the front foot.

The front of the torso is slightly concave.

The front of the torso creates a curved line that travels from the chest to the shoe.

The hair is droopy.

The lips are pursed.

The shoulders are pulled back.

Ruffle the hair to make him seem agitated.

Leave a slight space between his elbow and his body.

111

STROLLING

Strolling is depicted as an enjoyable action that is neither rushed nor purposeful. Characters do it when they daydream. It's used to break up the story by bringing some lightness to the scene.

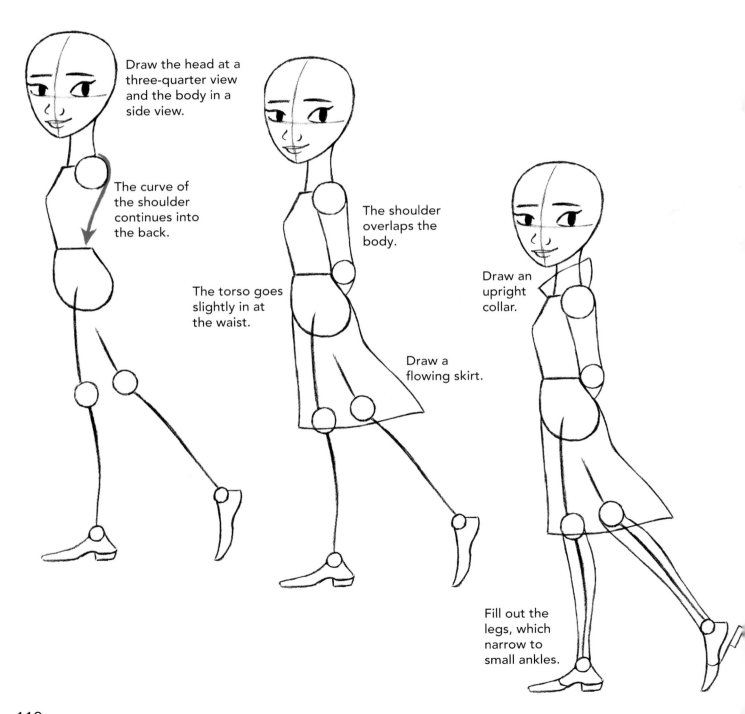

Draw the head at a three-quarter view and the body in a side view.

The curve of the shoulder continues into the back.

The torso goes slightly in at the waist.

The shoulder overlaps the body.

Draw a flowing skirt.

Draw an upright collar.

Fill out the legs, which narrow to small ankles.

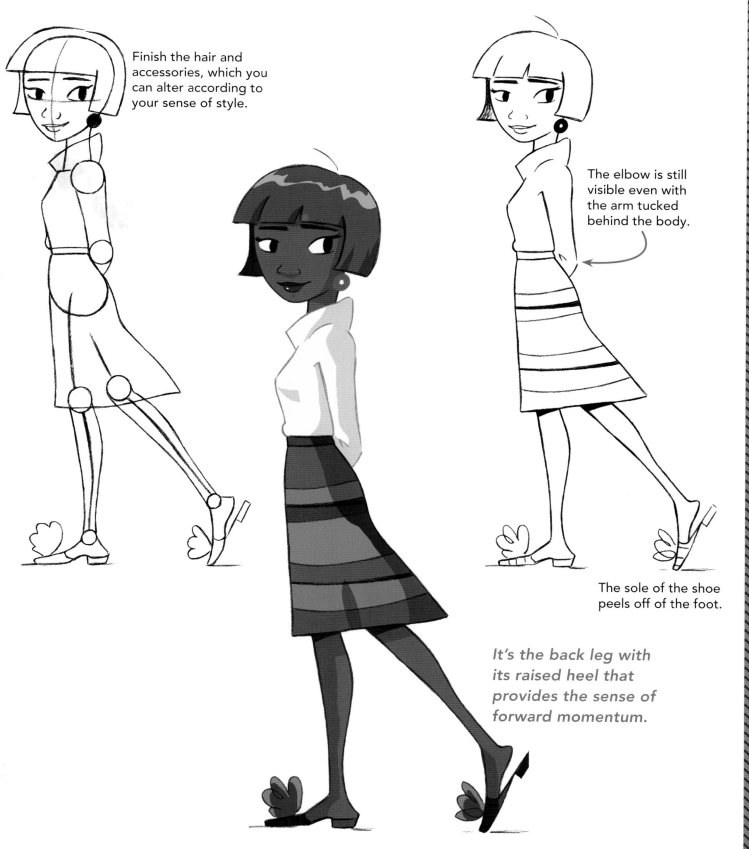

Finish the hair and accessories, which you can alter according to your sense of style.

The elbow is still visible even with the arm tucked behind the body.

The sole of the shoe peels off of the foot.

It's the back leg with its raised heel that provides the sense of forward momentum.

THE SHUFFLE

The shuffle is like a shrug, slump, and stroll mixed together. It's used when your character isn't excited to get where he's going. Maybe he's going to meet his girlfriend's brother for the first time. By the way, he's a cage fighter. The key is his back foot, which drags along, slowing his pace—on purpose!

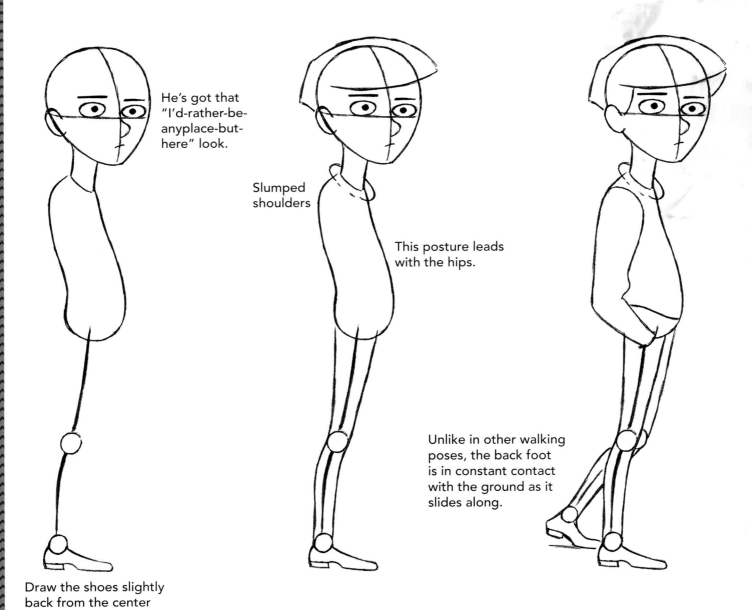

He's got that "I'd-rather-be-anyplace-but-here" look.

Slumped shoulders

This posture leads with the hips.

Unlike in other walking poses, the back foot is in constant contact with the ground as it slides along.

Draw the shoes slightly back from the center of the torso.

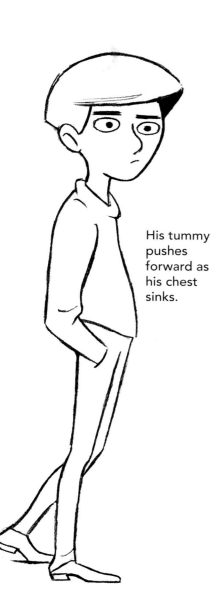

His tummy
pushes
forward as
his chest
sinks.

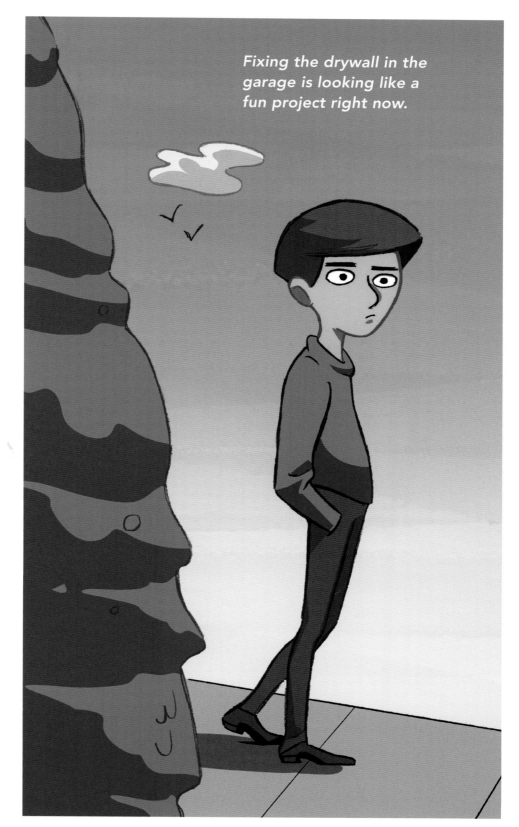

Fixing the drywall in the garage is looking like a fun project right now.

FRIENDLY POSE

A person making a friendly gesture generally leans toward the other person. It's a simple technique, which you can put to use with your own characters.

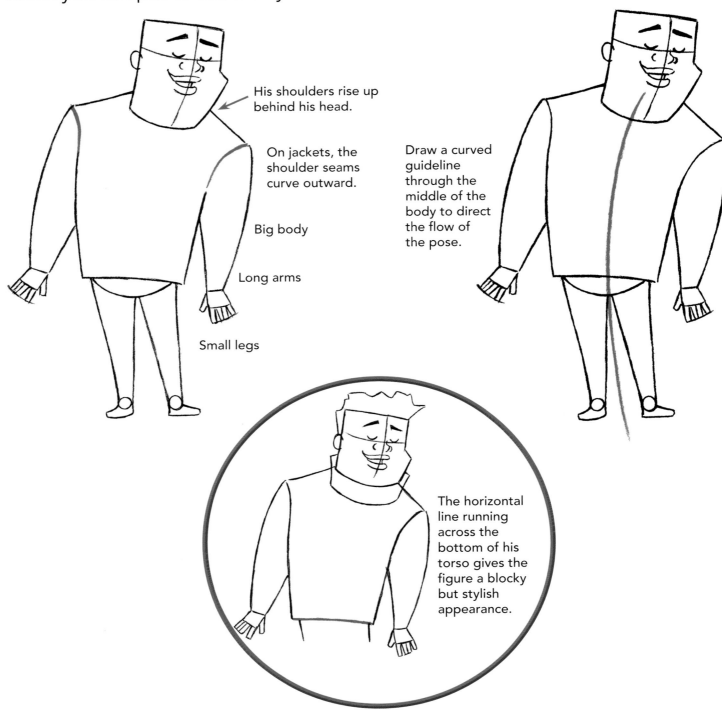

His shoulders rise up behind his head.

On jackets, the shoulder seams curve outward.

Big body

Long arms

Small legs

Draw a curved guideline through the middle of the body to direct the flow of the pose.

The horizontal line running across the bottom of his torso gives the figure a blocky but stylish appearance.

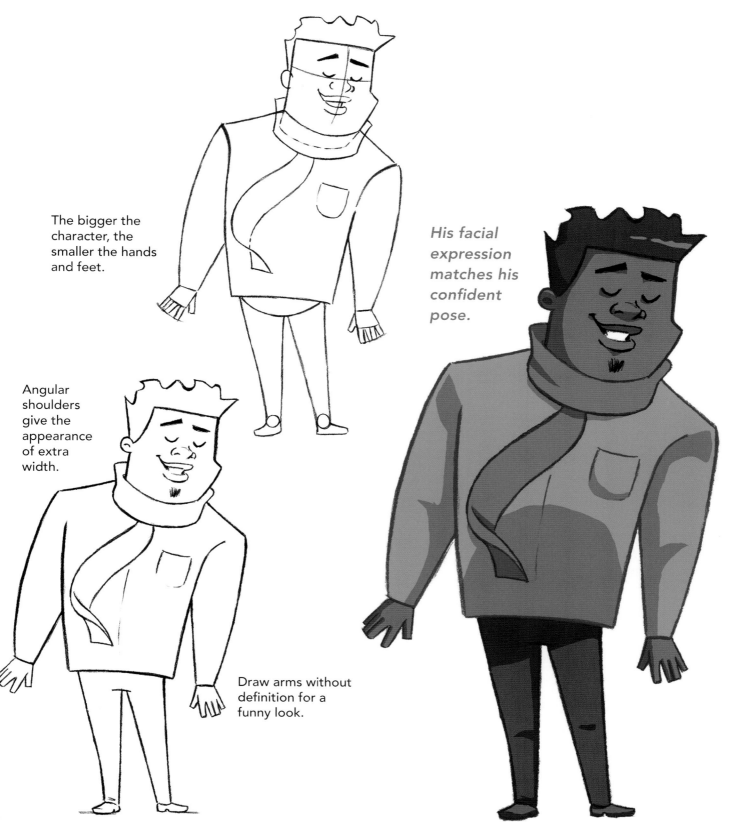

The bigger the character, the smaller the hands and feet.

His facial expression matches his confident pose.

Angular shoulders give the appearance of extra width.

Draw arms without definition for a funny look.

117

SITTING POSES

The age of a character influences his or her posture. Let's look at how a toddler sits compared to a teenager.

TODDLER

When a toddler sits, the upper body is stationery, but the arms are in constant motion. That might explain all the food on the walls.

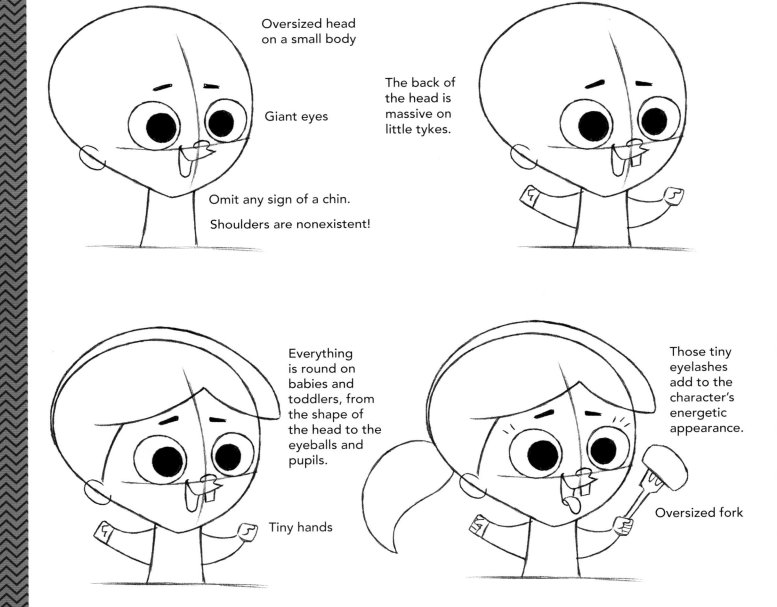

Oversized head on a small body

Giant eyes

Omit any sign of a chin.

Shoulders are nonexistent!

The back of the head is massive on little tykes.

Everything is round on babies and toddlers, from the shape of the head to the eyeballs and pupils.

Tiny hands

Those tiny eyelashes add to the character's energetic appearance.

Oversized fork

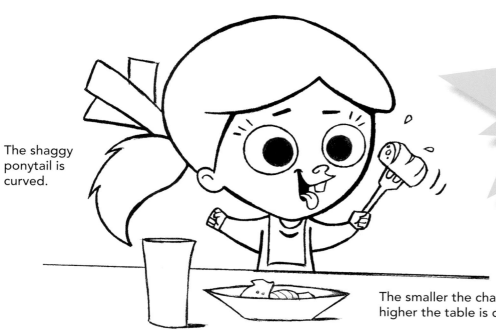

The shaggy ponytail is curved.

The smaller the character, the higher the table is drawn.

TIP
Younger characters are drawn with few, if any, contours to the outline of the head. It's basically a circle.

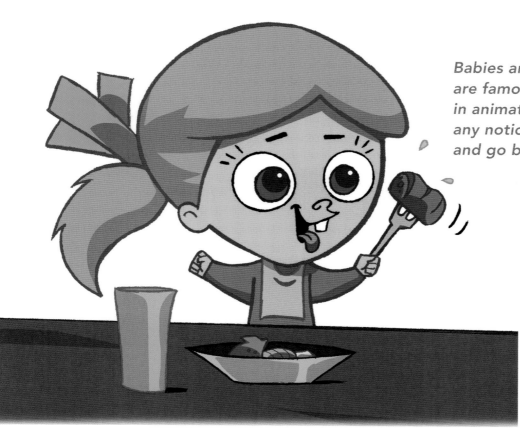

Babies and toddlers are famously stylized in animation. Toss out any notion of realism and go big!

TEEN

A teenage character sits very differently from a little kid. A teen's posture is more laidback. He will slink back in his chair, relaxed and in no hurry.

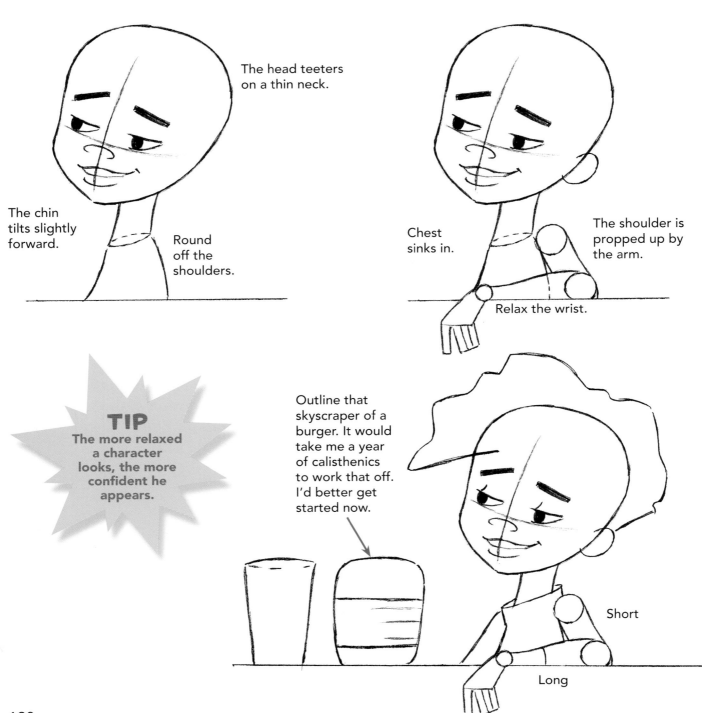

The head teeters on a thin neck.

The chin tilts slightly forward.

Round off the shoulders.

Chest sinks in.

The shoulder is propped up by the arm.

Relax the wrist.

TIP
The more relaxed a character looks, the more confident he appears.

Outline that skyscraper of a burger. It would take me a year of calisthenics to work that off. I'd better get started now.

Short

Long

120

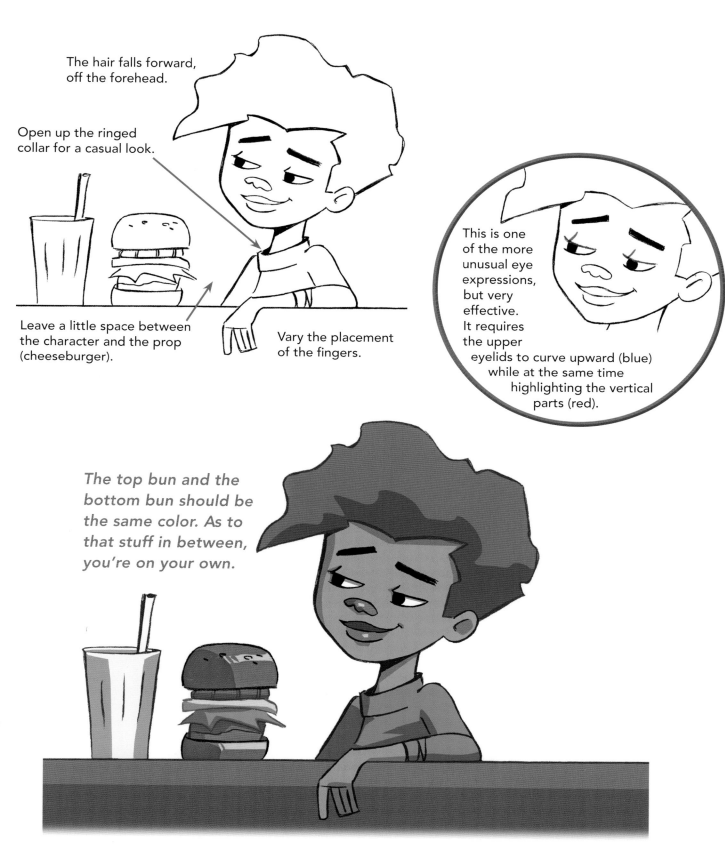

The hair falls forward, off the forehead.

Open up the ringed collar for a casual look.

Leave a little space between the character and the prop (cheeseburger).

Vary the placement of the fingers.

This is one of the more unusual eye expressions, but very effective. It requires the upper eyelids to curve upward (blue) while at the same time highlighting the vertical parts (red).

The top bun and the bottom bun should be the same color. As to that stuff in between, you're on your own.

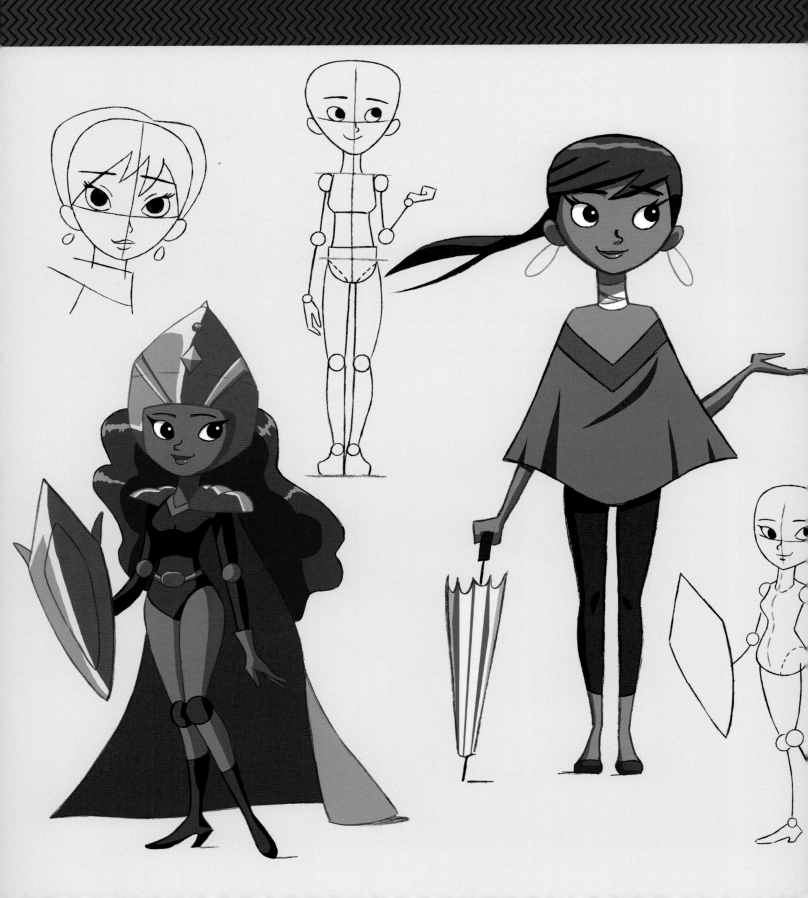

THE MASTER CHAPTER: CREATING VARIATIONS

This is a very important and useful chapter. Creating variations of characters is how cartoonists give themselves choices. It's also how we create stylistically related characters, such as a group of friends. But mainly, character designers and animators create variations to refine their ideas. Get ready to add some new techniques to your skill set.

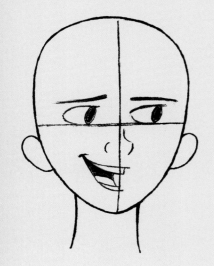

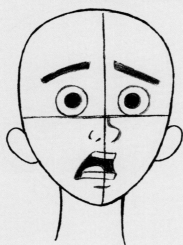

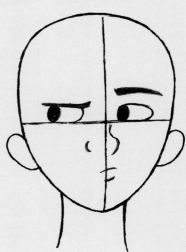

HAIRSTYLE VARIATIONS

There's no right or wrong haircut, but certain ways to draw them are more effective than others. These are the elements to look for:

- A cut that suits a particular character type
- A style that that can be described in one sentence
- A hairdo that enhances the look of the character

It's often unproductive to keep reworking the same concept. Sometimes, the right approach is a new approach.

SHORT AND CHIC

We'll start with a short cut with wispy bangs.

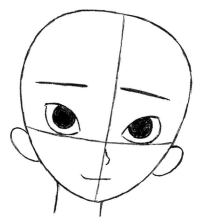

Because her head is tilted, the centerline and eyeline are at an angle.

On super-stylish characters, the little touches and accessories are important. So, I'm including earrings in the second step.

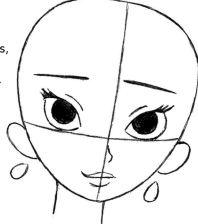

The hair dips at the part.

There's a lot of space between the head and the outline of the hair, which gives the hair more prominence.

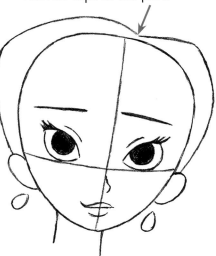

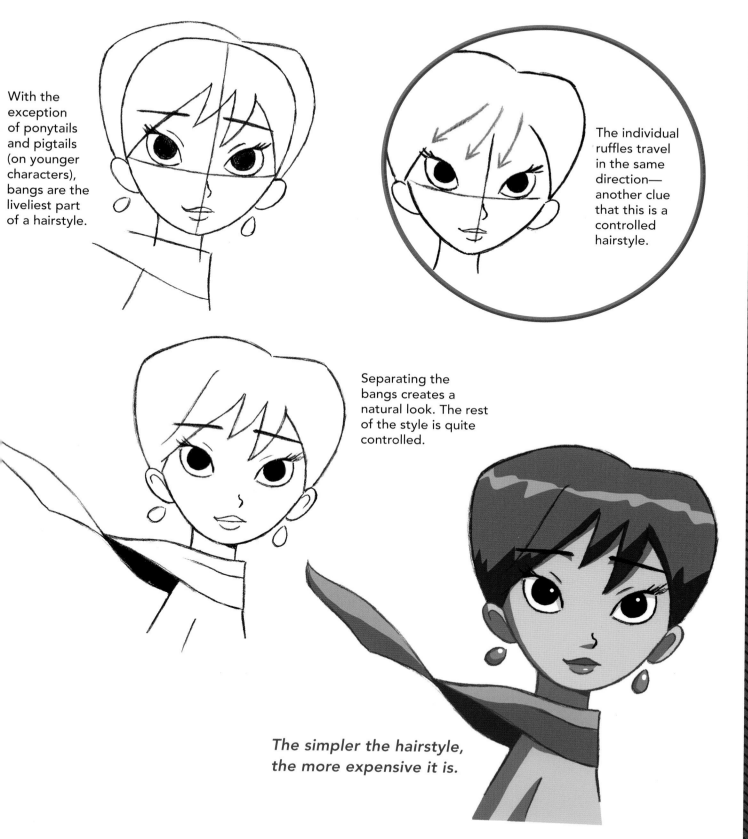

With the exception of ponytails and pigtails (on younger characters), bangs are the liveliest part of a hairstyle.

The individual ruffles travel in the same direction—another clue that this is a controlled hairstyle.

Separating the bangs creates a natural look. The rest of the style is quite controlled.

The simpler the hairstyle, the more expensive it is.

METROPOLITAN CUT

Keep in mind the shape of the head when drawing a hairstyle. The hair will always follow its contours to a greater or lesser degree.

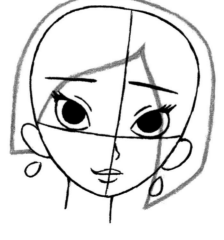 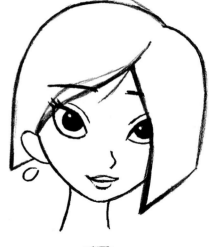

SHORT AND RUFFLED

This cut can be an attention-grabber. It's very trendy. It needs to be brushed so that the hair, which is choppy, flows in one direction.

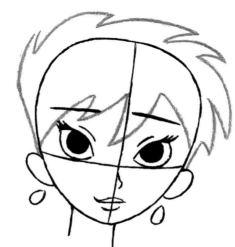 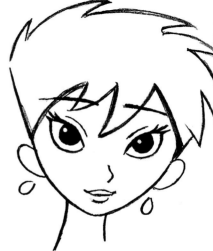

LONG AND FLOWING

This is one of the most popular cuts. It's really two cuts in one: long, flowing hair and long bangs, which dip below the eyebrows.

Don't forget to add a short hairline just above each ear.

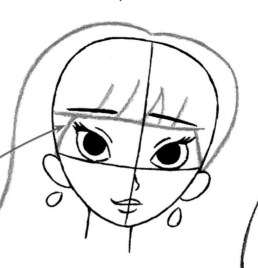 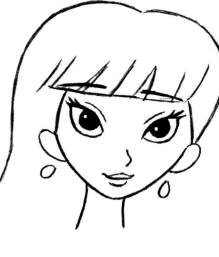

Changing the hairstyle can significantly redesign the look and attitude of your character.

HAIR AND GLASSES

In creating variations, why not widen your artistic tools to include glasses and hair, which you can show in a variety of combinations. Let's start with this friendly guy. It's interesting to see what happens when we keep his features intact, changing only his hair and glasses.

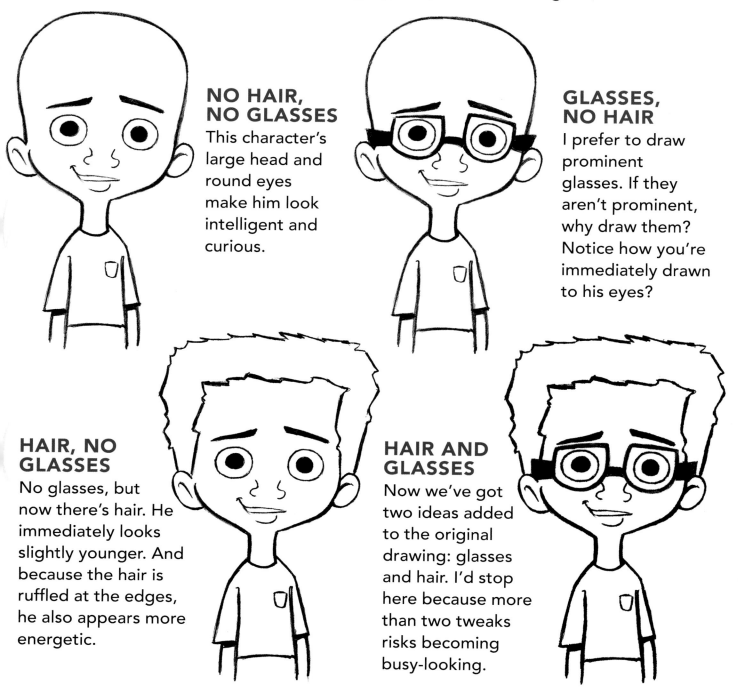

NO HAIR, NO GLASSES
This character's large head and round eyes make him look intelligent and curious.

GLASSES, NO HAIR
I prefer to draw prominent glasses. If they aren't prominent, why draw them? Notice how you're immediately drawn to his eyes?

HAIR, NO GLASSES
No glasses, but now there's hair. He immediately looks slightly younger. And because the hair is ruffled at the edges, he also appears more energetic.

HAIR AND GLASSES
Now we've got two ideas added to the original drawing: glasses and hair. I'd stop here because more than two tweaks risks becoming busy-looking.

127

CHANGING EXPRESSIONS

Creating variations also means creating different expressions, because a fully realized character needs an array of reactions. Let's start with the building blocks and work our way up.

DOUBTFUL EXPRESSION

This character's head is symmetrical. But the expression doesn't have to be. The eyebrows are uneven, and the mouth has been placed to one side.

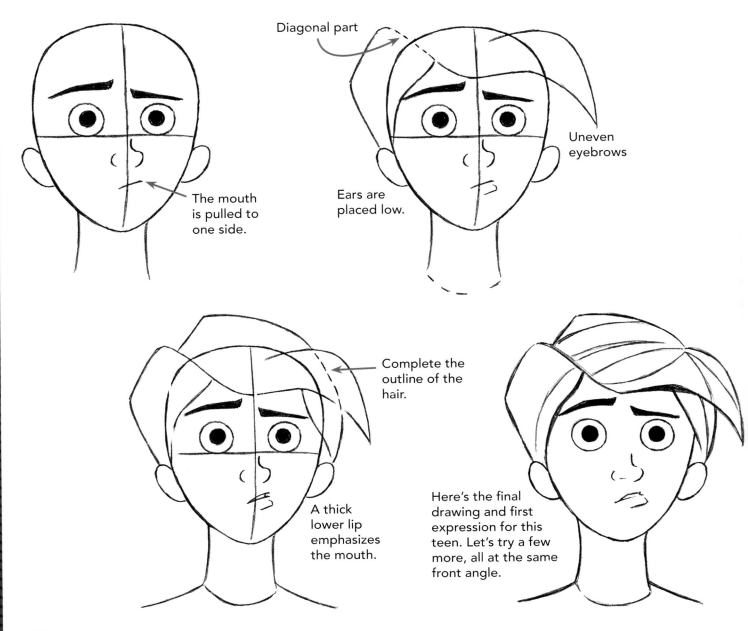

The mouth is pulled to one side.

Diagonal part

Uneven eyebrows

Ears are placed low.

Complete the outline of the hair.

A thick lower lip emphasizes the mouth.

Here's the final drawing and first expression for this teen. Let's try a few more, all at the same front angle.

ENTHUSIASTIC

Uncertain eyes combined with a smile mean he's predisposed to what he's hearing.

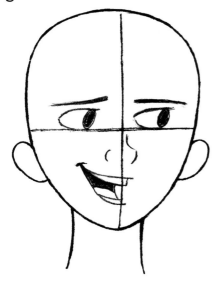

WARY

This expression is all about the eyes. The mouth shrinks and basically gets out of the way!

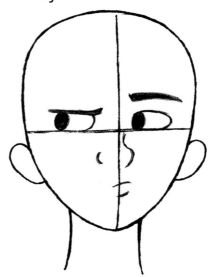

FEARFUL

I think you can guess which expression this is. He just found out that homework has been assigned over the summer.

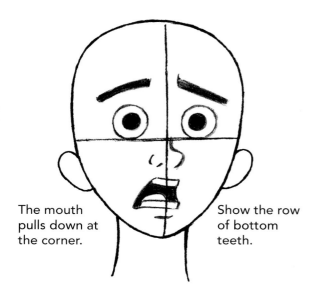

The mouth pulls down at the corner.

Show the row of bottom teeth.

CHEERFUL

For another variation on the cheerful expression, try drawing him with his eyes closed and the same smile.

The upper eyelids are rounded, but the bottom ones are flat.

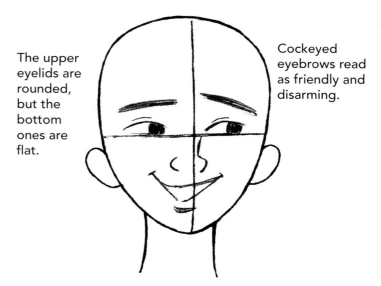

Cockeyed eyebrows read as friendly and disarming.

CLOTHES MAKE THE CHARACTER

In this example, one character could star in a fashion shoot, while the other conquers a local mountain ridge. But they're the same character! Do clothes actually change the identity of a character? Yes, they do!

HAPPY CAMPER

The basic construction doesn't need to be adjusted for each character. The clothes create all the difference necessary.

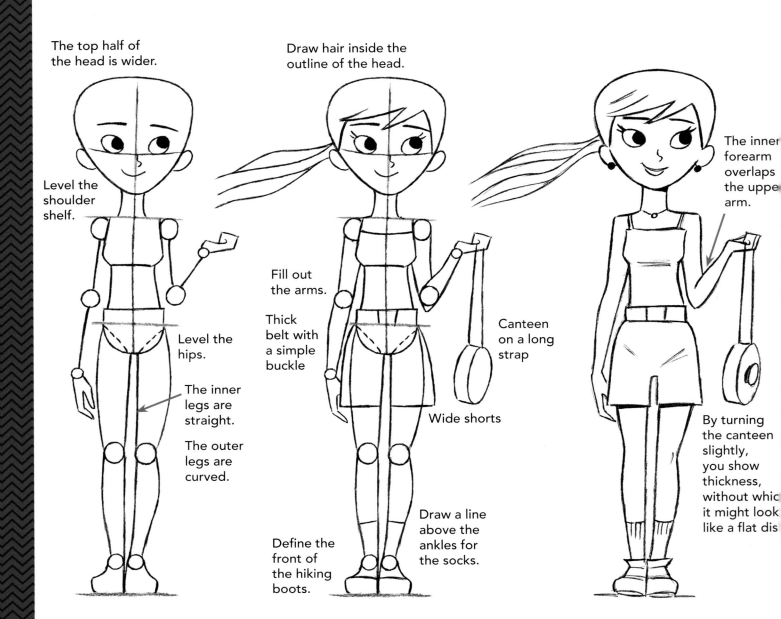

The top half of the head is wider.

Level the shoulder shelf.

Level the hips.

The inner legs are straight.

The outer legs are curved.

Draw hair inside the outline of the head.

Fill out the arms.

Thick belt with a simple buckle

Define the front of the hiking boots.

Canteen on a long strap

Wide shorts

Draw a line above the ankles for the socks.

The inner forearm overlaps the upper arm.

By turning the canteen slightly, you show thickness, without which it might look like a flat dis

CITY SLICKER

Our hiker has changed for a day on the town. Her poncho, leggings, and hoop earrings are simple but stylish. You barely notice it's the exact same character.

TIP
Whatever style of clothes you choose, use the simplest version. Simple is easily understood by the eye.

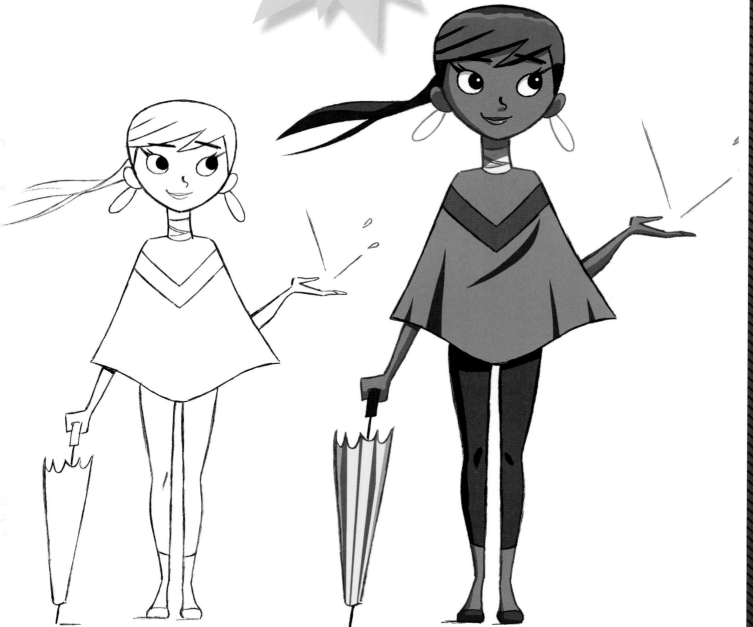

FUN WITH COSTUMES

An effective way to create variations is to place your character in a different genre or time period, like the Middles Ages with princesses and knights. To do this, you'll have to dress them in the right costumes.

PRINCESS

To create a soft, flowing costume without losing the shape of the figure, work some contours into the outfit from the start of the drawing.

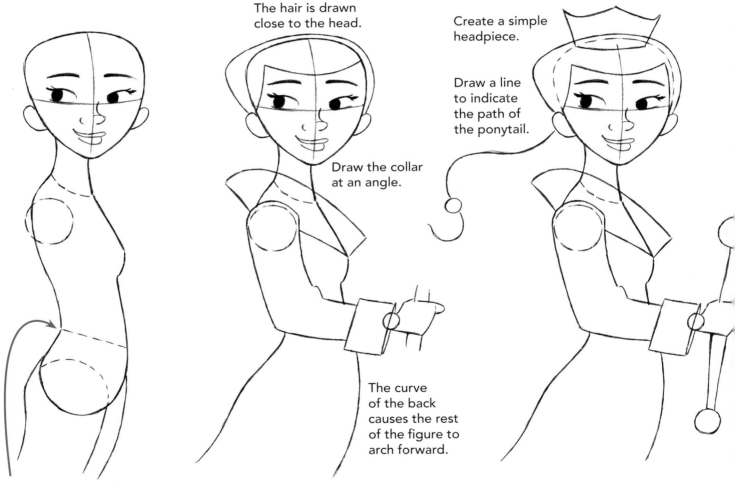

The hair is drawn close to the head.

Draw the collar at an angle.

Create a simple headpiece.

Draw a line to indicate the path of the ponytail.

The curve of the back causes the rest of the figure to arch forward.

To keep the pose lively, exaggerate the contours, like the one in her lower back.

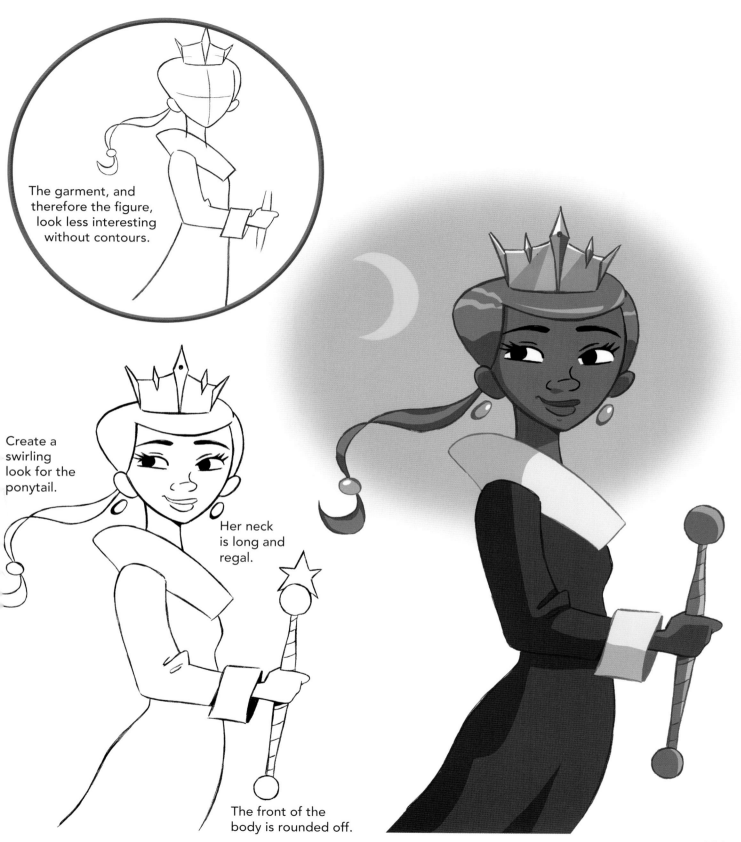

The garment, and therefore the figure, look less interesting without contours.

Create a swirling look for the ponytail.

Her neck is long and regal.

The front of the body is rounded off.

KNIGHT

You can't have a story set in the Middle Ages without a knight. Have fun with these characters! These outfits often include props, such as a helmet, a shield, and shoulder guards, and you can change the style of a knight's suit of armor as easily as you change the style of a skirt or blouse.

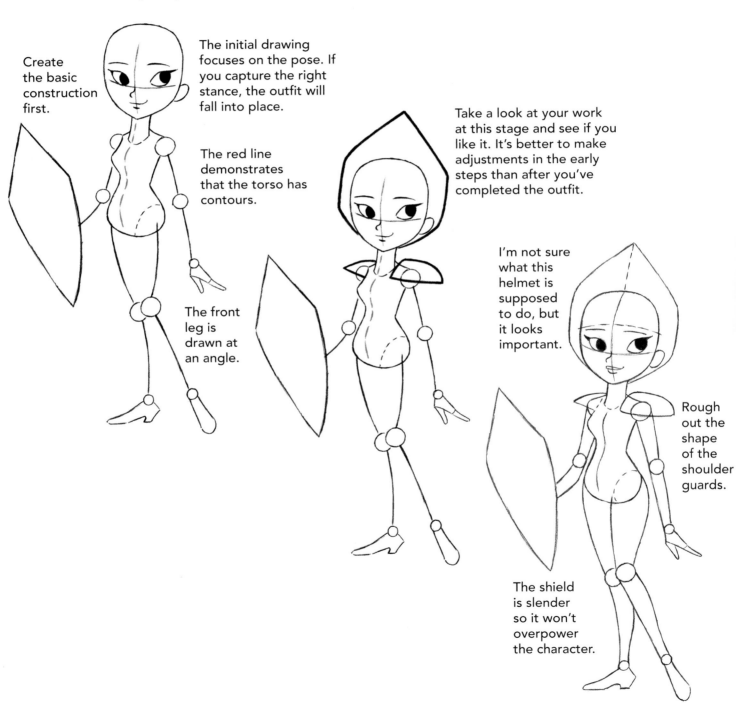

Create the basic construction first.

The initial drawing focuses on the pose. If you capture the right stance, the outfit will fall into place.

The red line demonstrates that the torso has contours.

The front leg is drawn at an angle.

Take a look at your work at this stage and see if you like it. It's better to make adjustments in the early steps than after you've completed the outfit.

I'm not sure what this helmet is supposed to do, but it looks important.

Rough out the shape of the shoulder guards.

The shield is slender so it won't overpower the character.

A character that is not super-exaggerated can get away with an oversized head if the proportions look logical.

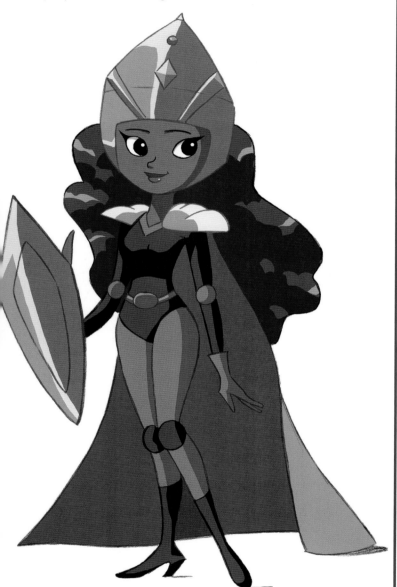

Is she from the future? Or the past? Or the future combined with the past, which would the puture? I didn't think so either.

A DIFFERENT LOOK

Here's another classic knight character. Try "deconstructing it." That means drawing the steps by analyzing the finished version. Analytical thinking is an important tool in character creation.

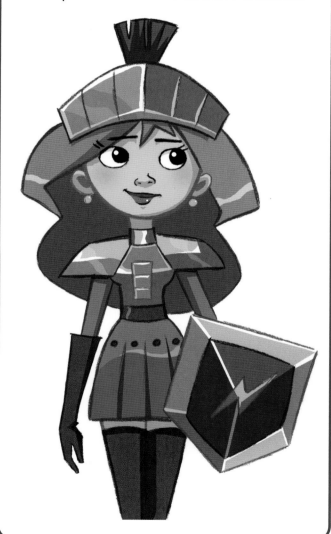

POSES: CREATING ALTERNATIVES

Have you ever drawn a pose and decided that it just didn't work, so you threw it out? Not so fast! Professional artists save their rough sketches. You never know when inspiration will strike and you can finish them.

BASIC CONCEPT (ARMS DOWN)

You may have thought that this pose was about arm placement. To some extent it is, but at the core, this pose is about stretching the upper body.

TIP
In many poses, the shoulders gain prominence when the arms are pulled back.

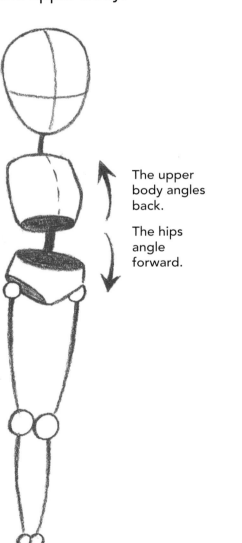

The upper body angles back.

The hips angle forward.

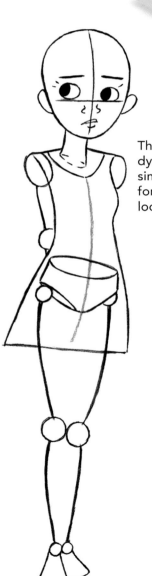

The body dynamics are simplified for a cartoon look.

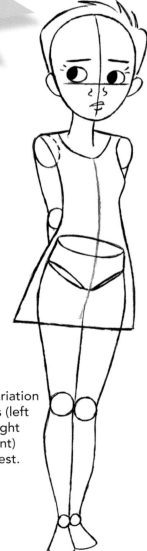

A slight variation of the legs (left straight, right slightly bent) adds interest.

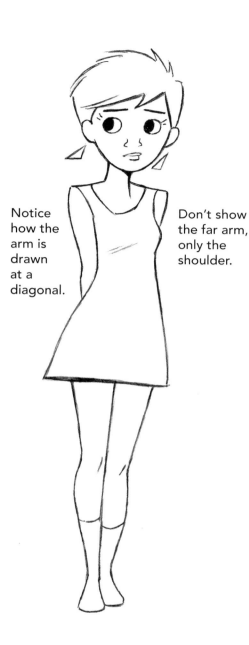

Notice how the arm is drawn at a diagonal.

Don't show the far arm, only the shoulder.

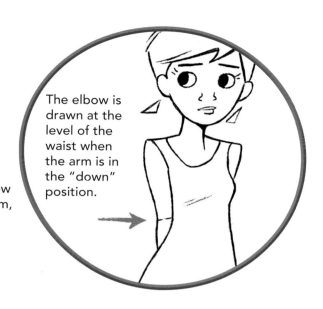

The elbow is drawn at the level of the waist when the arm is in the "down" position.

CONCEPT: ARMS CROSSED

Here's the same character with one change: The arms are crossed in front of her body. She's using them as emotional protection.

When arms are crossed in front of the body, the elbows are always drawn lower than the hands and wrists.

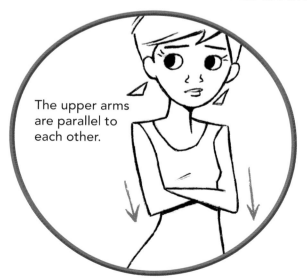

The upper arms are parallel to each other.

CHANGE THE PROPORTIONS, CHANGE THE CHARACTER

We're all aware that when you change a proportion, like adding big shoulders, you change the look. But some changes force you to make other changes. For example, if you change a character's height, you also have to change their other proportions.

TALL GUY

Let's build an average guy, then see the effect when we change his height.

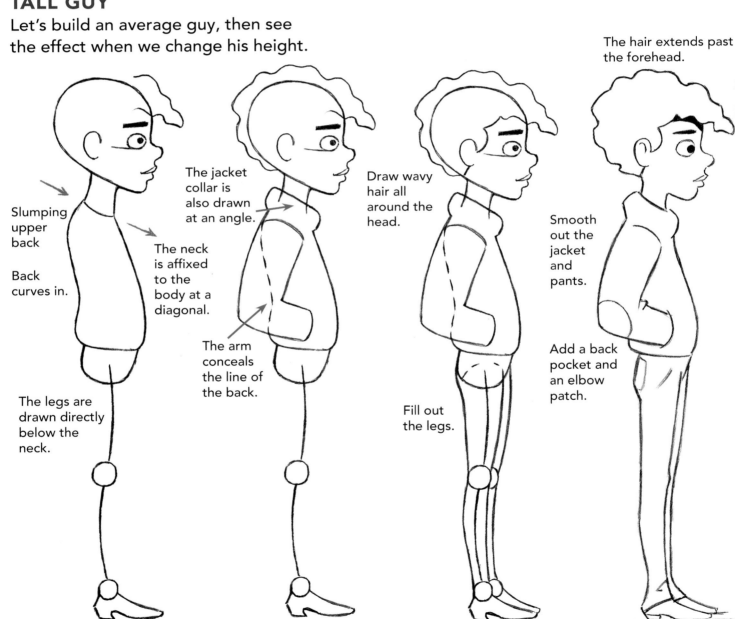

The hair extends past the forehead.

Slumping upper back

Back curves in.

The legs are drawn directly below the neck.

The jacket collar is also drawn at an angle.

The neck is affixed to the body at a diagonal.

The arm conceals the line of the back.

Draw wavy hair all around the head.

Fill out the legs.

Smooth out the jacket and pants.

Add a back pocket and an elbow patch.

SHORT GUY

When we shorten a character, we have to compensate for the reduced height so he doesn't just look like he shrank. To do this, add some padding to the figure, which makes the character look younger. Now, the new proportions match the reduced height.

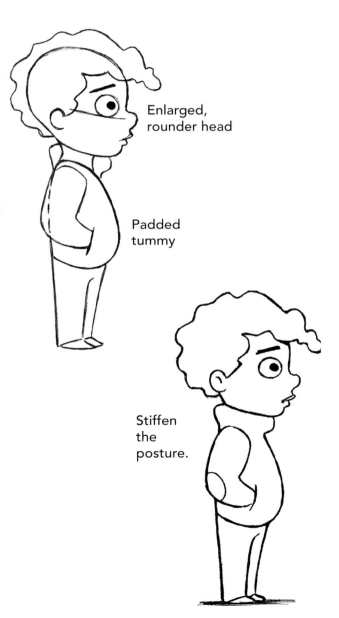

Enlarged, rounder head

Padded tummy

Stiffen the posture.

You wouldn't cast these guys in the same adventure role. And yet, they derive from the same character. That's the key to character design.

TALL VS. SHORT

Notice how in the adult character, the body proportions are unequal, while the kid's proportions are roughly equal.

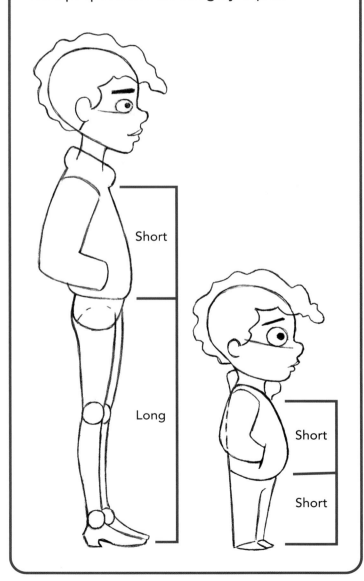

Short

Long

Short

Short

ARM GESTURES

Whenever you draw a body, you're drawing a pose. The easiest way to create a new pose is to generate it from an existing one. The changes can be subtle and still make a big difference. Check out how it works.

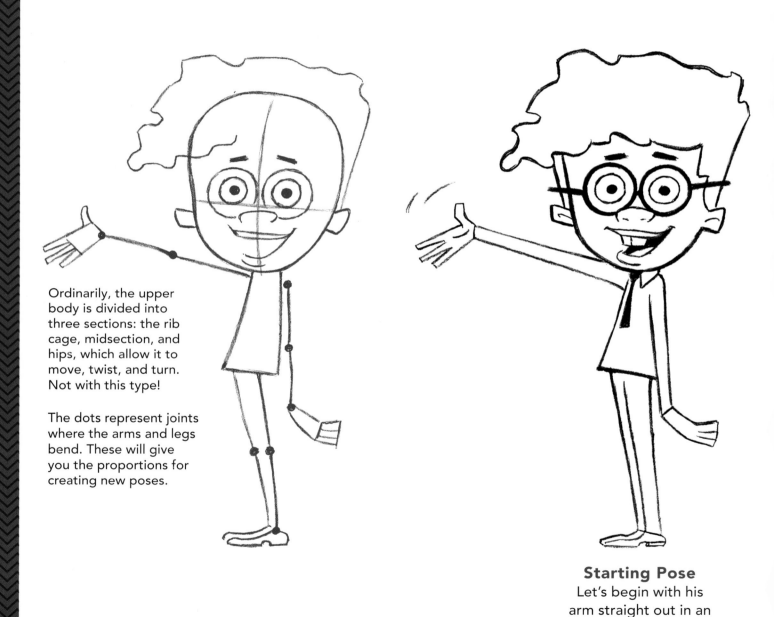

Ordinarily, the upper body is divided into three sections: the rib cage, midsection, and hips, which allow it to move, twist, and turn. Not with this type!

The dots represent joints where the arms and legs bend. These will give you the proportions for creating new poses.

Starting Pose
Let's begin with his arm straight out in an enthusiastic gesture.

TIP
As you create new characters, look for opportunities to change the position of an arm or a leg, while retaining the basic character design.

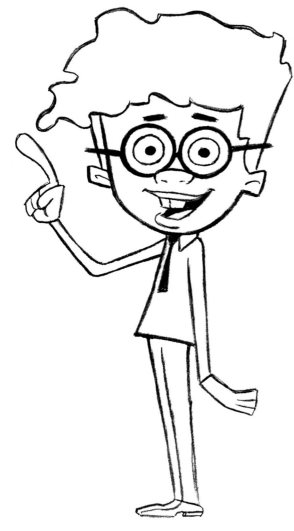

Variation: Front Arm
By merely pointing his finger, this pose becomes about having an epiphany!

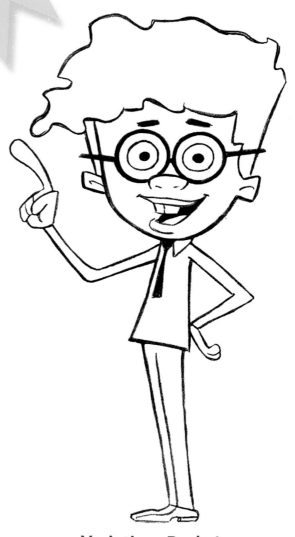

Variation: Back Arm
To go one step further, bring in the other arm. It looks quite different from the original pose. But the upper body hasn't moved at all!

BEND AND FLEX

We'll end with an important but lesser-known concept in cartooning: Using flexibility—or lack of it—as part of character design. It's easy to incorporate, once you know what it is, and now you know! Give it a try.

STIFF BACK

These are fun, goofy types. A straight vertical line from the neck to the shoes really gets the point across. The front of the figure can remain round.

KNOCK-KNEES

This flexibility can be localized. Here it appears only in the knees, where it creates a cute backward bend.

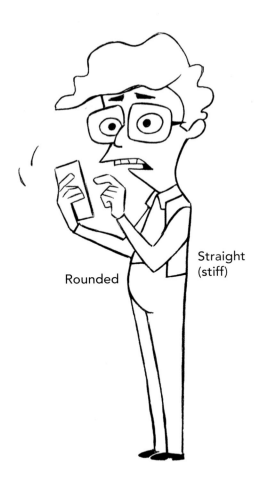

Rounded

Straight (stiff)

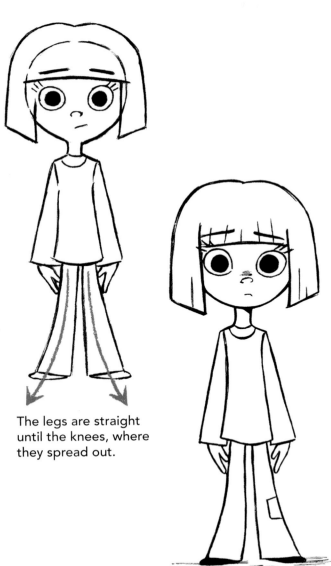

The legs are straight until the knees, where they spread out.

HYPEREXTENDED

Some characters are hyperflexible. This gives them a fluid, expressive look. And this hyper-flexibility is apparent even when the clothes cover most of the basic construction. Let's try it out.

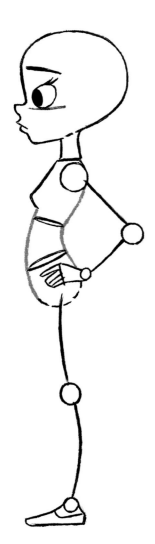

For exaggerated flexibility, focus on both sides of the torso. If the back of the torso moves, it will exert pressure on the front.

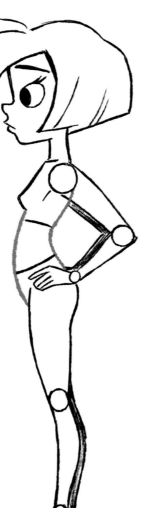

More places in the body to find hyper-flexibility are elbows, shoulders, and the neck, especially in mopey expressions.

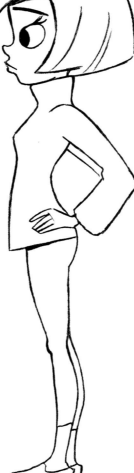

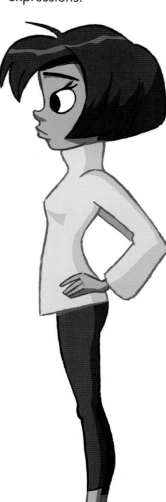

The shoulders and hips are aligned, one on top of the other. But between them, the torso get noodly!

Flexibility, evident even when this character wears a bulky turtleneck sweater, gives a character the look of being ready to jump into action.

INDEX